IMAGES of America
RAYMOND

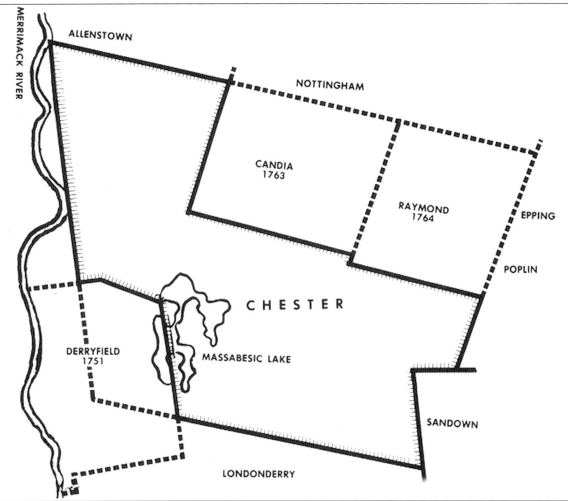

RAYMOND TOWN LINE, 1764. This shows how the towns that comprised Chester were divided and incorporated. (Courtesy of Joyce Wood.)

On the cover: **PARADE, 1914.** These sons of Raymond's Civil War veterans are waiting to join the sesquicentennial parade. The flag they are carrying is on display at the Raymond Historical Society. It is a commemorative flag made in honor of Raymond's Civil War hero John E. Cram. (Courtesy of the Raymond Historical Society.)

IMAGES of America
RAYMOND

Kristin Ozana Doyle

Copyright © 2008 by Kristin Ozana Doyle
ISBN 978-0-7385-5739-7

Published by Arcadia Publishing
Charleston SC, Chicago IL, Portsmouth NH, San Francisco CA

Printed in the United States of America

Library of Congress Catalog Card Number: 2007937578

For all general information contact Arcadia Publishing at:
Telephone 843-853-2070
Fax 843-853-0044
E-mail sales@arcadiapublishing.com
For customer service and orders:
Toll-Free 1-888-313-2665

Visit us on the Internet at www.arcadiapublishing.com

*To my grandfather Victor Peter Ozana,
because you have always been so proud of me, and because
I will continue to love and adore you all the days of my life.*

Contents

Acknowledgments		6
Introduction		7
1.	Around Town	9
2.	Business and Industry	31
3.	Organizations, Associations, and Institutions	49
4.	The 1914 Sesquicentennial Celebration	59
5.	School Days	75
6.	Homes, Inns, and Taverns	87
5.	Raymond Residents	105
7.	Bibliography	126
8.	Index	127

Acknowledgments

This book would not have been possible without all the help and guidance I received from Joyce Wood and Sally Guptill Paradis. Joyce may not have grown up in Raymond, but she is a native at heart and extremely knowledgeable about the town. Her personal collection of postcards and her insight initially propelled me, and she spent countless hours helping me sort through photographs and information. I also need to make sure that Sally knows how extraordinarily helpful she was in tracking down names, dates, and information for me. She grew up in this town and knows just about everyone and everything that has gone on in Raymond for the past half century. I was grateful to have both these women as wonderful resources.

I also want to thank the Raymond Historical Society for its willingness to give me free reign of the enormous collections it has compiled. Your generosity is much appreciated.

There were many individuals who contributed photographs, postcards, and most importantly, stories that I am eternally grateful for: Shirley Holt Dodge; Alison Welch LaCasse; the Waterhouse sisters, Judy Foley and Jean Edgerly Saladino; Bill and Elaine Harmon; Susan Hilchey; Peg Louis; Robert H. Cammett; Jon McCosh; Mary Wheadon; David Baker; Linda Hoezel at the Dudley-Tucker Library; and Fire Chief Kevin Pratt. And a very special thank-you to Steve Goldthwaite for spending hours letting me pour over his extensive personal collection and also for entertaining me with stories of our shared hometown.

To my Raymond High School students: If you take anything away from this book, I hope you realize that you have a hometown to be proud of. Never stop learning and never stop asking questions. And thank you to John Adams for your helpful suggestions.

I do not think I could have made it through this project with my sanity intact if it was not for the love, support, and encouragement of my family and my husband, Brian. You all have been so excited to see the finished product that your enthusiasm really kept driving me. I hope I continue to make you proud.

Introduction

Always a small town at heart, Raymond lies nestled along the Lamprey River, in what remains today a largely rural town. Raymond may be poised today to enter a new era of growth and development, but there is a large contingent in the town that is making sure that its past is being preserved. In fact, as one enters Raymond, there are many signs that read, "Preserving our Past, Preparing our Future." It is a town that has the unique ability to look both forward and backward at the same time.

Raymond's history actually begins as a part of the neighboring town of Chester. This entire area had exchanged hands between colonists and Native Americans for nearly a century, with the first land deeded to Rev. John Wheelwright in 1638 from a Sagamore Indian. On May 11, 1717, Col. Stephen Dudley of Exeter purchased the area that is now Raymond from a Native American named Peter Penuit, after the native peoples had regained occupation of the land. This area became known as Freetown and was included in the incorporation of Chester on August 27, 1726. Two years after it was incorporated, Chester was divided into 140 hundred-acre lots, although some were larger. After 1740, the town began to be settled quite quickly.

The town of Raymond became incorporated on May 9, 1764, and was aptly named after Capt. William Raymond (or Rayment) of Beverly, Massachusetts, who raised a company of soldiers to fight in a war against Canada in the early 1700s. In its earliest days, the town was primarily an agricultural and logging community, with many farms and mills dotting the landscape. There are still many families in town that can trace their ancestors to some of these earliest settlers.

Raymond, like many other rural New England towns, was transformed by the railroad. The idea for a railroad to pass through Raymond originated in 1844, when the population of the town was still under 1,000, and those were mostly farmers. The Railroad Proprietor Convention was held on July 22, 1845, with the purpose of drumming up investors to buy stock in the railroad. The Portsmouth and Concord Railroad opened its Raymond stop to the public on September 9, 1850. Three years later, the 47-mile line to Concord was completed. The total cost of the project was $1,003,608.60. The railroad itself would go through a series of identities: the Portsmouth and Concord, the Concord and Portsmouth, the Concord Railroad Company, the Concord and Montreal, and finally, in 1895, the Boston and Maine. Once the railroad came to town, growth and change were slow but steady. The trains brought new materials into town and took lumber out of town, resulting in new industries developing and booming. The center of town, near the train depot, began to house more shops and inns to accommodate new residents and visitors.

This begins a time of a dual identity for the town. Shoe manufacturing took off in two different factories, but there were also many chicken farms scattered around town in addition to smaller

family-owned farms. Just at the very time the town of Raymond was starting to thrive, it also received what could have been its biggest setback. On the night of December 5, 1892, a fire was discovered burning in one of the downtown buildings. When it was finally put out early the next morning, the entire downtown Main Street area was in ruins, with 25 buildings and all but one business being destroyed.

At the time of the great fire, Raymond did not have its own fire department. Two years earlier, in 1890, the Concord railroad offered to furnish the town with a water tower, but for unknown reasons, the town declined the offer. It took only a little over a year after the great fire for the department to get organized. The first department consisted of 18 members, and these members chose to name their company Torrent Hose.

It has not only been the railroads that have helped bring new people to town. The old Route 101 (now State Route 27) was completed in 1938, linking Hampton with Keene. In 1984, the new Route 101 was completed, allowing a much easier passage from Manchester to the Atlantic Ocean via Raymond. The highway was dedicated to Robert C. Erler, a former selectman and representative to the general court. It was after this infrastructure was put in place that numerous housing developments started to be constructed. A number of housing areas in town can trace their roots to the 1970s, when builders came to Raymond in anticipation of a population boom due to the easier access. New housing developments are still going in today due to the centralized location of Raymond and its accessibility to Portsmouth, Manchester, Concord, and Boston.

Before Raymond became known as a popular bedroom community, it was a well-known vacation stop on the Boston and Maine rail line. Containing over 300 acres of water within its borders, the town became an attractive resort community, with a number of summer boardinghouses on the town's lakes. Onway Lake was particularly popular, not only with out-of-town vacationers but also with young men and women visiting summer camps. Probably the best known was Camp Se-Sa-Ma-Ca, run by Mary T. Sargent for over 50 years. Also along Onway Lake were a number of rental cabins and inns, which drew a number of visitors from surrounding states. Again, the town's accessibility by railway made it a very desirable place to vacation. While Raymond's lakes might not have the boardinghouses anymore, there is a campground in Pawtuckaway Lake State Park and also a popular private campground, Pine Acres, which still continue to draw out-of-state visitors.

To speak about the residents of Raymond is to speak of their generosity. Many institutions have relied on volunteers and have thrived because of them. In 2007, the recreation department celebrated its 30th year sponsoring educational and recreational programs throughout the year, including its highly successful summer playground. The Raymond Youth Athletic Association is administered by volunteers who maintain fields, coach teams, and construct buildings. In its early years, both the Raymond Fire Department and ambulance were run exclusively by volunteers. Today full-time professionals in addition to volunteers service these organizations. There are also a number of opportunities for young people to volunteer in town as well.

There has been a lot of business interest in Raymond in recent years. The town is currently in the final planning stages to bring an outlet mall, condominiums, and a hotel to an area next to exit 4 off Route 101. This will undoubtedly bring even more visitors to the town that so many residents continue to take pride in. Throughout negotiations with developers, many residents have worked to maintain the integrity and small-town feel of Raymond. Maintaining its identity is very important to a town that has gone through fires and floods and booms and busts. We want to look back and preserve what we have, while we make way for the future of our town to unfold.

One
AROUND TOWN

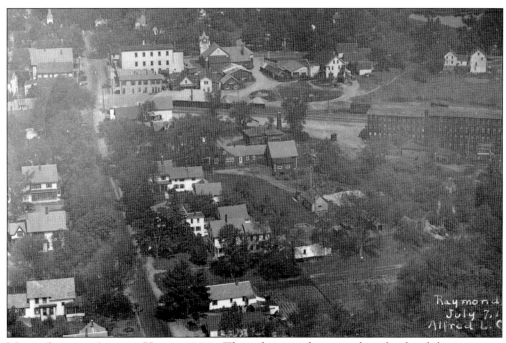

MAIN STREET AERIAL VIEW, 1940. This photograph was taken by local businessman Alfred Gosselin. Along the left side of the picture runs Main Street to the north. The train depot and downtown businesses can be seen in the top left. (Courtesy of the Raymond Historical Society.)

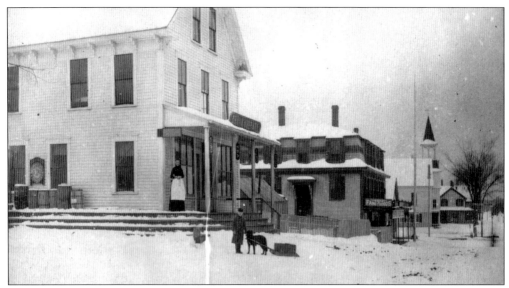

MAIN STREET BEFORE FIRE, 1892. This is one of the few photographs that shows the downtown area before the great fire of 1892. This view is looking south on Main Street, with the Methodist church steeple in the background. This is on the corner of Church Street and Main Street. (Courtesy of the Raymond Historical Society.)

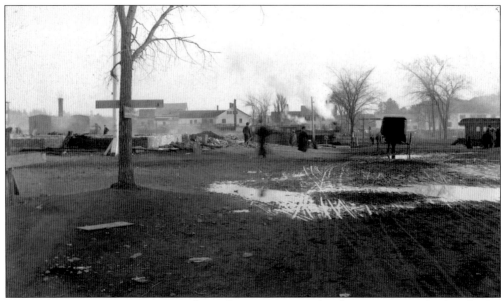

MAIN STREET AFTER FIRE, 1892. This is the same view as the above picture, only after the fire in December 1892. Church Street is to the left. The devastation of the downtown blocks can be seen here. High winds were responsible for the fire spreading quickly. (Courtesy of the Raymond Historical Society.)

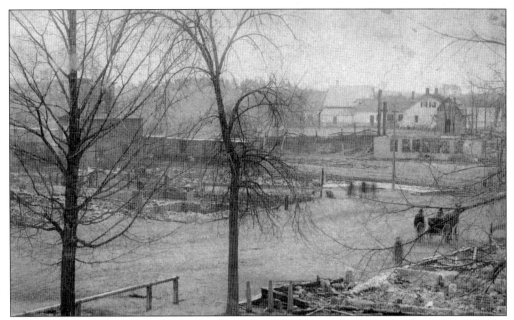

MAIN STREET, LOOKING SOUTHEAST, 1892. The great fire completely devastated the downtown area. The ruins of the Methodist church (on the land where the Catholic church would eventually be built) can be seen to the right of the photograph. The ruins of the train depot can be seen through the trees. (Courtesy of the Raymond Historical Society.)

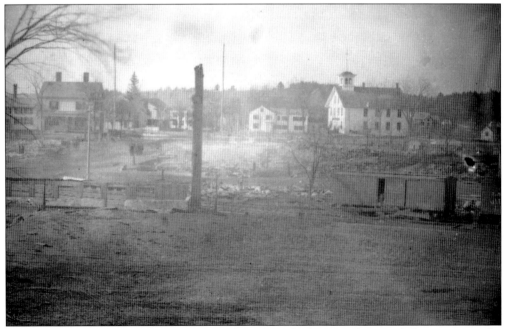

MAIN STREET, LOOKING NORTH, 1892. This view is looking north toward the common. The town common prevented the fire from spreading beyond the town's center. The town hall can be seen in the background. The total loss in the fire was around $110,000. (Courtesy of the Raymond Historical Society.)

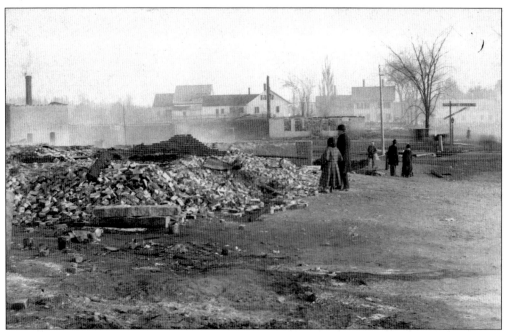

EAST BLOCK OF MAIN STREET, 1892. The Manchester Fire Department had a steam engine to Raymond in 18 minutes via the railroad. Both Manchester and Portsmouth Fire Departments arrived and pumped water from the Lamprey to help with the fire. The post office burned, but the postmaster managed to save its contents. (Courtesy of the Raymond Historical Society.)

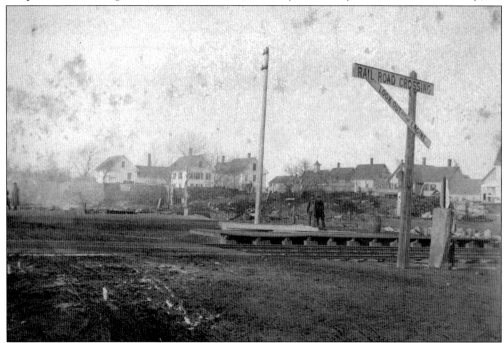

GREAT FIRE OF 1892. The people in this photograph are standing on what was the depot landing. This fire destroyed 25 buildings and all but one store in town. (Courtesy of the Raymond Historical Society.)

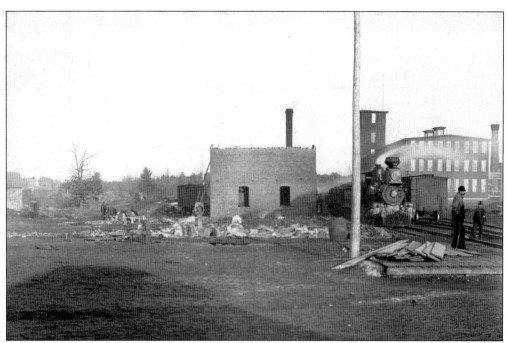

REMAINS OF TRAIN DEPOT, 1892. The Hoitt Shoe Factory can be seen in the background. The Hoitt employees created a bucket brigade to help keep the fire away from the factory. (Courtesy of the Raymond Historical Society.)

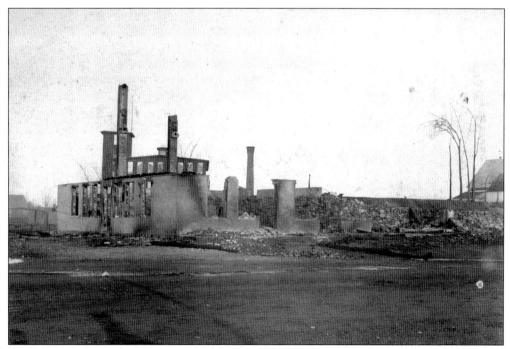

REMAINS OF METHODIST CHURCH, 1892. Before the fire, the Methodist church was built beside the train tracks. It was after this fire that the church was moved near the common. (Courtesy of the Raymond Historical Society.)

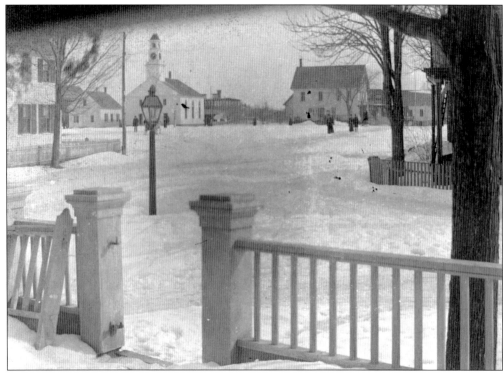

COMMON VIEW, BEFORE AND AFTER 1892 FIRE. These are two very rare photographs that were taken from the home of Dr. True M. Gould, on the corner of Main Street and Old Manchester Road, right before and right after the 1892 fire. The Congregational church and its parsonage can be seen in the first picture, as well as the east side of Main Street. The shoe factory behind the depot can be seen clearly in the second picture. (Courtesy of the Raymond Historical Society.)

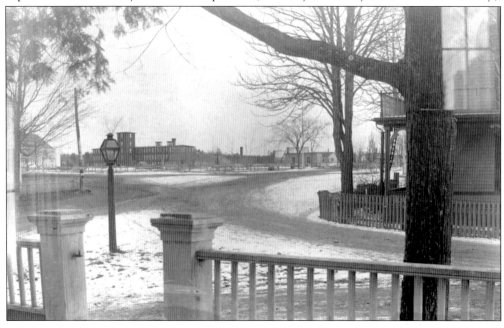

HARRIMAN ROAD, JUNE 1946. Most of the houses in this photograph are still standing, and the area itself looks very similar, except the road is now paved. (Courtesy of the Raymond Historical Society.)

LONG HILL ROAD. This photograph shows one of the oldest roads in Raymond, Long Hill Road, near the town's border with Candia. The house on the left still stands, but the house on the right burned down. (Courtesy of Joyce Wood.)

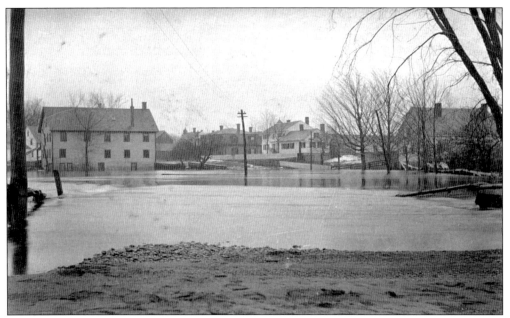

PECKER BRIDGE FLOOD, 1900. This flood of the Pecker Bridge took place on February 15. The Lamprey River at this point can get quite high in the spring, but it is not very often that the entire bridge is covered like it is in this picture. (Courtesy of the Raymond Historical Society.)

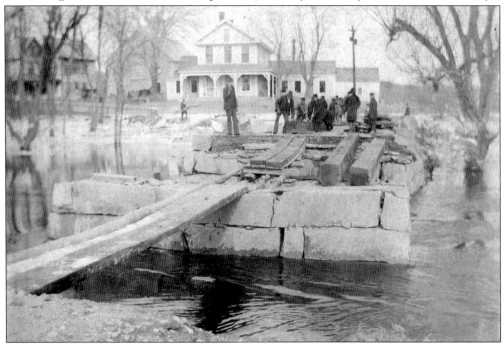

PECKER BRIDGE REBUILDING, 1900. These men are trying to rebuild the Pecker Bridge after the February 15, 1900, flood. This was quite a daunting task, and it required quick action. Pecker Bridge links the east part of Raymond with the downtown area. With the bridge impassable, travel through town was made quite difficult and time consuming, especially in the era of horse and buggy. (Courtesy of the Raymond Historical Society.)

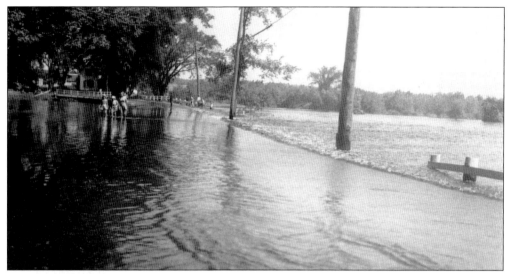

PECKER BRIDGE FLOOD, 1938. This flood of the Lamprey River took place in August 1938, one month before a large hurricane moved through Raymond, bringing more rain and flooding. No one can remember why the river was flooded in August, but a few brave souls took to the bridge to observe the phenomenon. This area of the Lamprey River is quite prone to flooding. The bridge was rebuilt in the 1990s to help withstand the frequent flood events. (Courtesy of Shirley Holt Dodge.)

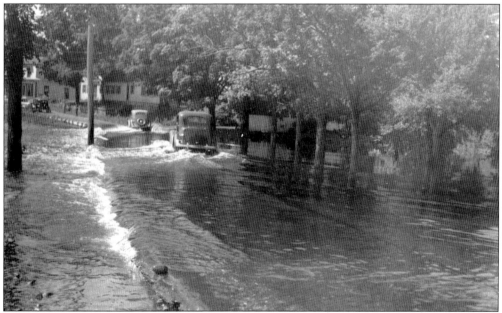

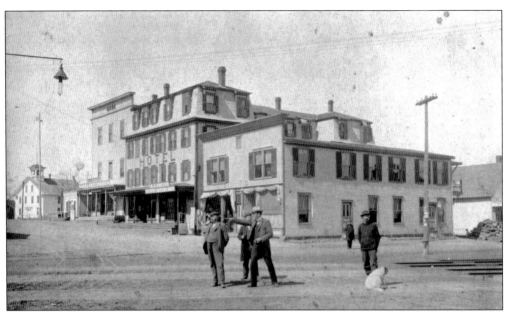

MAIN STREET, C. 1910. The east side of Main Street can be seen here. This was before the second-story porch was added to the New Raymond House Hotel. (Courtesy of the Raymond Historical Society.)

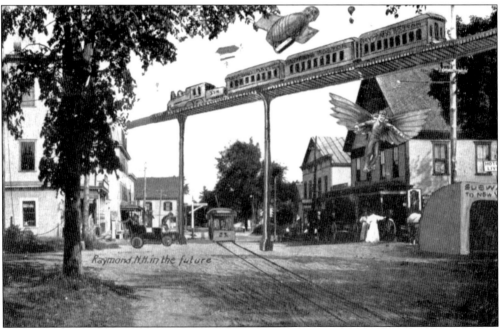

RAYMOND OF THE FUTURE? This is a postcard in a series that took real photographs and had an illustrator imagine what that location would look like in the "future." The original of this photograph, which can be found at the Raymond Historical Society, was taken in the late 1800s on Main Street. Notice to the far right a sign reads "Subway to New York." (Courtesy of Joyce Wood.)

COMMON VIEW OF MAIN STREET. This photograph was taken from the common around June 1943. (Courtesy of the Raymond Historical Society.)

MAIN STREET, 1946. This view of Main Street is looking south, toward the train depot. Candyland and Smith's Market can be seen on the left side, while Hazel's Diner can be seen on the right. (Courtesy of the Raymond Historical Society.)

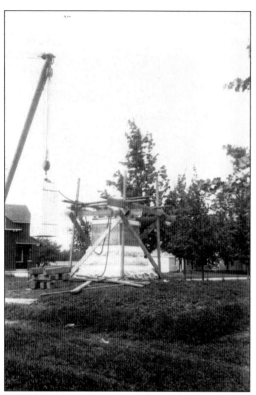

MONUMENT BASE, 1910. The Civil War monument base is shown here being built in 1910. The cost of the monument was near $2,500. The monument stands 25 feet, 8 inches in height and is made of Barre granite and Quincy polished granite. On the other sides of the base are the names of the veterans. In the spring of 1912, the statue was blown off its pedestal in a windstorm and needed to be fastened more securely. (Courtesy of the Raymond Historical Society.)

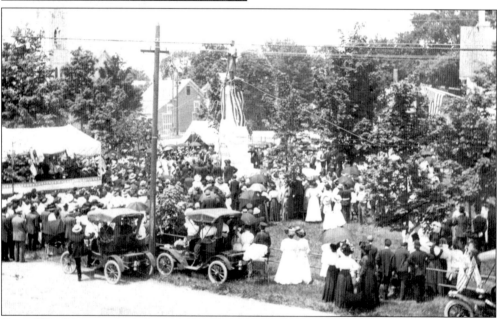

CIVIL WAR MONUMENT UNVEILING. The monument was unveiled on June 21, 1910, by Vivian Cram (age 6), granddaughter of Raymond's Civil War hero John E. Cram. Some people believe that the statue is actually made to be a likeness of Cram. Three thousand people were there to watch the unveiling. The legend goes that the statue was moved to face south as a "lesson to the southerners to watch out." (Courtesy of Joyce Wood.)

RAYMOND'S WORLD WAR I SOLDIERS. Many of Raymond's residents came out to bid some of their boys farewell before they left for Europe during World War I. (Courtesy of Joyce Wood.)

WORLD WAR I MONUMENT UNVEILING. This monument to Raymond's World War I veterans was unveiled by Betty Plant and Rosmar Fox on Memorial Day in 1926. This monument is located in front of the town library. (Courtesy of the Raymond Historical Society.)

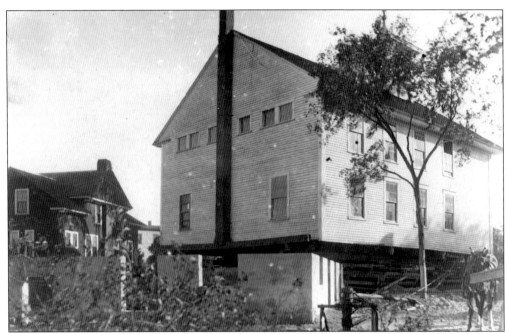

TOWN HALL. The building of this town hall actually took 30 years. A frame was originally built in 1759, only to be taken down the year after to help rebuild the bridge now known as Pecker Bridge. In 1786, this structure was finally completed. The town hall was moved several times, first from its location near the present safety complex in 1797. Then, in 1857, it was moved forward a few feet toward Epping Street. Two years after the building was put on a foundation in 1915, the structure burned to the ground. (Courtesy of the Raymond Historical Society.)

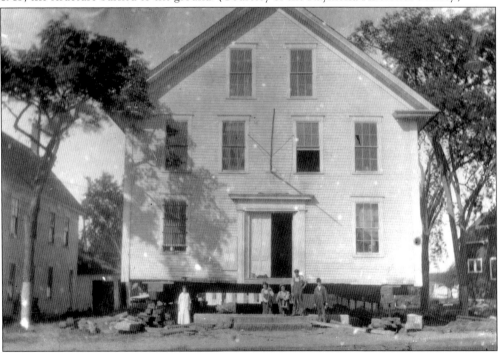

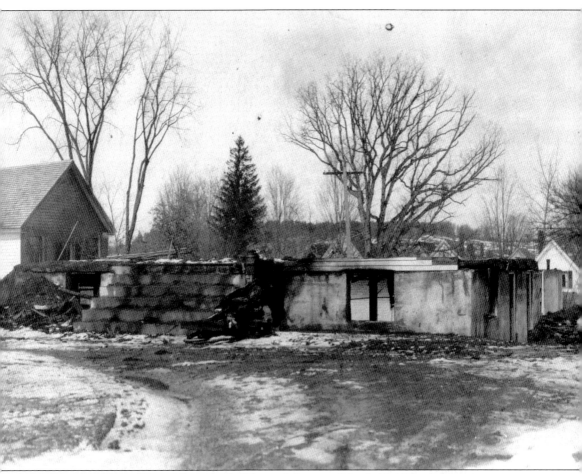

REMAINS OF TOWN HALL. The town hall burned down on March 13, 1917, after a town meeting, and the cause remained unknown. The top was capped off, and it was then used as a town shed until a new town hall was built. Some people in town remember when the jail was located in the capped-off basement. Until the new town hall was built in 1974, the offices were located in the upper floor of the library. (Courtesy of the Raymond Historical Society.)

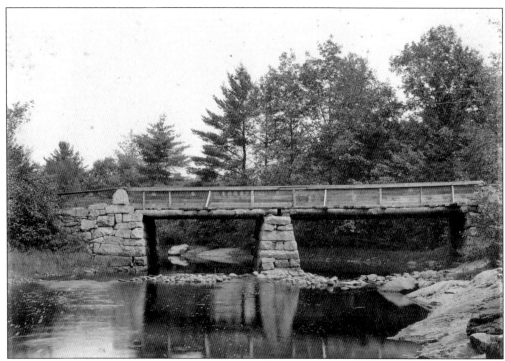

GRIFFIN BRIDGE. This bridge is just as one turns onto Langford Road from old Route 101. This bridge also floods frequently in the springtime. This is an older photograph that shows the bridge before it was completely rebuilt in the 1990s. (Courtesy of the Raymond Historical Society.)

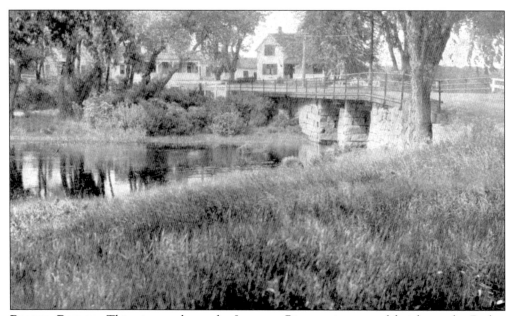

PECKER BRIDGE. This picture shows the Lamprey River at its normal height at the Pecker Bridge. This is also an older photograph of the bridge before it was made more structurally sound. (Courtesy of Joyce Wood.)

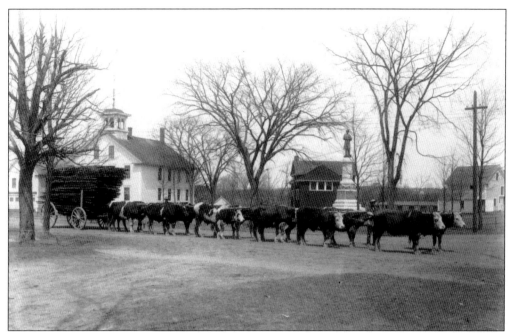

HAULING LUMBER ON MAIN STREET. Ben Brown of Deerfield (not pictured) used to haul lumber from his farm to the Raymond freight yard to be shipped out. This photograph was taken around 1910, and the Civil War monument can be seen on the common. (Courtesy of the Raymond Historical Society.)

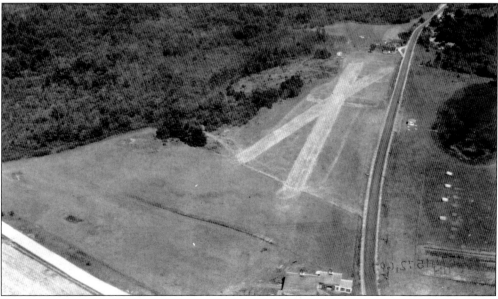

RAYMOND AIRPORT. William Brown owned the field for this airport, currently the site of the Route 107 baseball fields, near the Fremont line. It was primarily used for student instruction, but chartered trips and scenic flights were also available. The two dirt runways measured 1,000 feet. Built in 1920, it was closed by the defense department after the bombing of Pearl Harbor in 1941, as were all general aviation airports within 50 miles of the coast. (Courtesy of the Raymond Historical Society.)

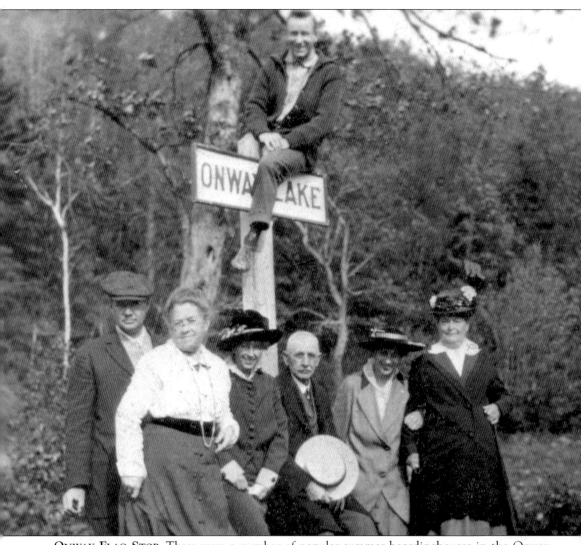

ONWAY FLAG STOP. There were a number of popular summer boardinghouses in the Onway Lake area, but there was no depot or platform at the Onway Lake stop. In order to get on or off the train, one had to flag down the train. (Courtesy of Joyce Wood.)

HUTCHINSON THEATER. This 100-seat community theater was planned and designed in 1951 by Susan B. Hutchinson of Pennsylvania. The theater included a stage, an orchestra, and mezzanine seating, and the chairs were all at different levels, so they were higher in back and people had to climb into them. Hutchinson ran the theater for five summers until her death in 1956, attracting both Raymond residents and actors from New York and Boston for her productions. It reopened for two summers in 1962 and 1963 and then again from 1967 to 1971. The former playhouse is no longer standing due to a heavy snowstorm. There were also housing and dining facilities for the actors on the property, and the Hutchinson family still vacations there in the summers. (Courtesy of the Raymond Historical Society.)

HUTCHINSON THEATER, ACTORS' QUARTERS. This building contained the actors' quarters and the dressing room for the Hutchinson Theater. Today this is a private residence, and the steps were removed due to their deteriorated condition. (Courtesy of Susan Hilchey.)

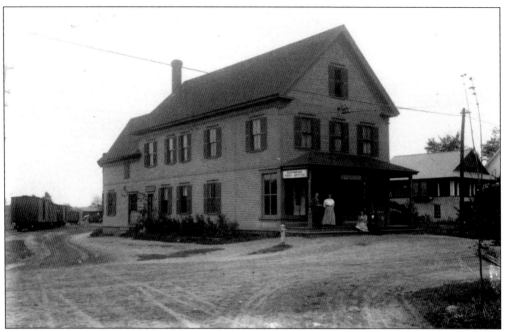

POST OFFICE AFTER THE GREAT FIRE. The post office was located in this building from 1914 until 1942, when it moved across Main Street. The hours of the post office were from 7:00 a.m. to 9:00 p.m. This building later became the Catholic church. (Courtesy of the Raymond Historical Society.)

THIRD POST OFFICE. This was the third location for the post office, from 1965 to 1996, when it was moved to the larger location in the Raymond Shopping Center on Freetown Road. This building is currently occupied by RSL Layout and Design and the New Hampshire Surveyors Association. (Courtesy of the Raymond Historical Society.)

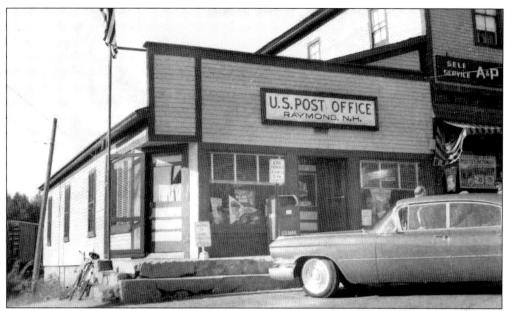

POST OFFICE BLOCK, C. 1946. The post office was at this location (far left below) from 1942 to 1965. Prior to that, the building was used as a grain and coal store. (Courtesy of the Raymond Historical Society.)

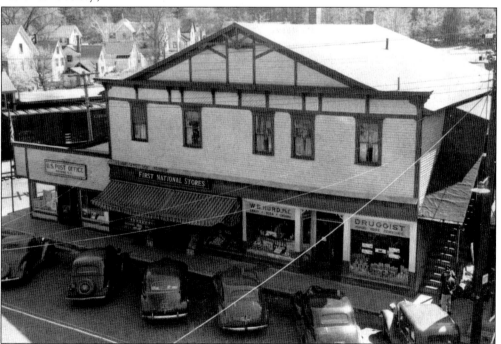

MAIN STREET IN WINTER. This photograph is looking north on Main Street. The building that currently houses the Brewitt Funeral Home can be seen on the right, and Old Manchester Road begins on the left. (Courtesy of the Raymond Historical Society.)

MAIN STREET IN WINTER. This photograph is looking south on Main Street. The Whittier Clothing House is the second building on the right. The dark building on the far left is the building that used to house the post office and the Catholic church. It is now apartments. (Courtesy of the Raymond Historical Society.)

Two
BUSINESS AND INDUSTRY

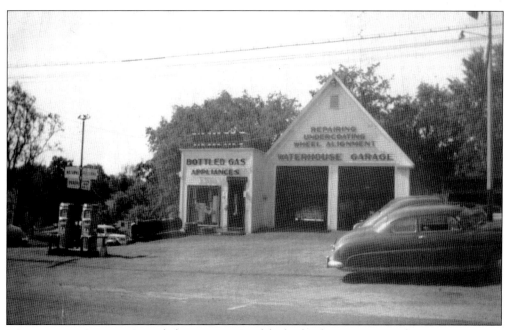

WATERHOUSE GARAGE. Founded in 1940 as a Ford dealership by Grover Waterhouse, a prominent man around town, this garage was in business through 1965, at which point Waterhouse began to breed and race horses. (Courtesy of the Raymond Historical Society.)

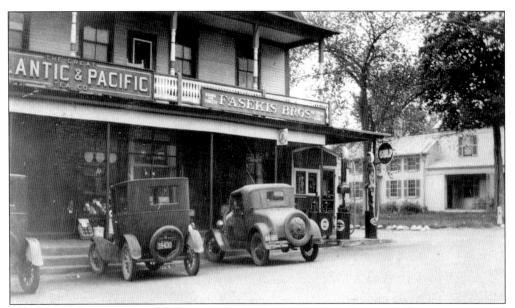

A&P AND FASEKIS BROTHERS STORE. The Fasekis brothers, Andrew and George, immigrated to the United States from Romania in 1913 and opened their store on Main Street in 1916. For 35 years, Andrew and his wife, Annie, lived above the store, and then in 1950 they bought the house next door on the corner of Main Street and Wight Street, known then as "the Old Bean Place." The home would later be demolished when a bank bought the land in the late 1970s. (Courtesy of the Raymond Historical Society.)

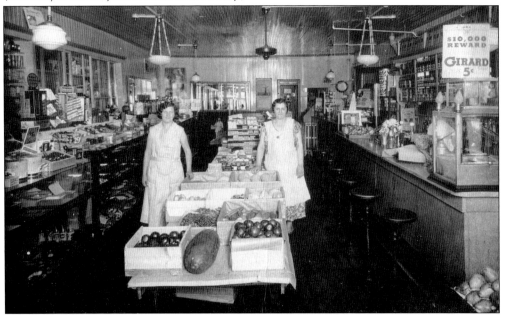

INSIDE THE FASEKIS STORE. Raymond resident Clara Hall Teague (left) and owner Annie Fasekis stand inside the Fasekis' Fruit Store during the 1930s. Notice the "$10,000 Reward" sign in the upper right-hand corner of the picture. The blue eagle emblem can see seen at the top of the sign. This was the symbol of Pres. Franklin Roosevelt's National Recovery Act program. (Courtesy of the Raymond Historical Society.)

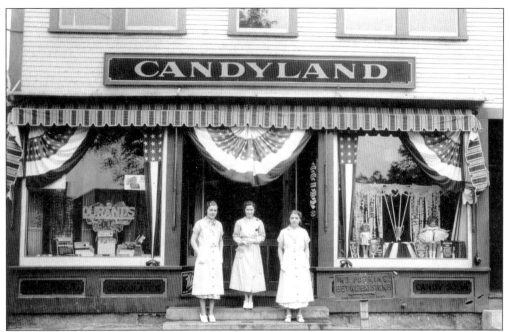

CANDYLAND. This photograph of, from left to right, Ellen Cooper, Mary Pitman, and Vera Pitman was taken shortly after Candyland was renovated and expanded in 1948. This location was also the bus stop for the Interstate Lines, a Manchester-to-Portsmouth bus route during the 1940s and 1950s. (Courtesy of the Raymond Historical Society.)

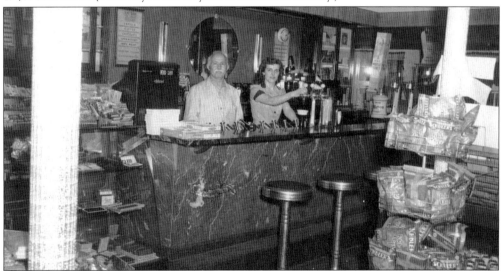

INSIDE CANDYLAND. Owner Jimmy Pappadim is pictured with Florence Brown Langille. Langille, along with her four sisters, was a waitress at the store and took over when Pappadim died in 1948. This store was located on the corner of Main Street and Church Street, where Howard and Company Certified Public Accountants is now. Candyland made its own ice cream and was a gathering place for teenagers. Pappadim is remembered as being very kind, quiet, generous, and well-liked by all. He was born in Ronese, Greece, and came to the United States in the early 1900s. Later the Brown sisters sold Candyland and it became Kris Kringle and then Bessie's Lunch. (Courtesy of the Raymond Historical Society.)

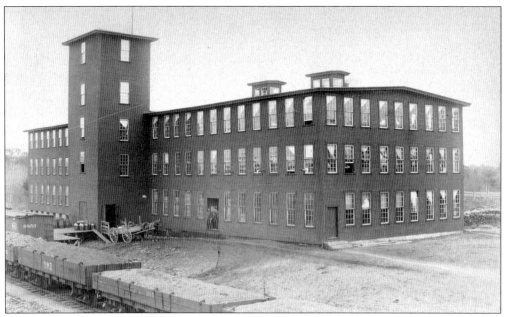

CHASE CHAMBERLAIN SHOE FACTORY. The Chase, Chamberlain and Company Shoe Factory was located behind the train depot. During World War II, the factory was known as the Bourque Shoe Factory, which was under government contract to make Lend-Lease shoes and shoes for nurses. Since this was considered essential business, workers could not strike or quit to seek employment elsewhere. (Courtesy of the Raymond Historical Society.)

FALCONER SHOE SHOP. This building was built in 1892 as the Healey and Brown Shoe Factory. Then it became the A. P. Brown and Company Shoe Factory, the L. K. Morse Shoe Company Shoe Factory, the Falconer and Feely Shoe Factory, and finally the F. W. Falconer Shoe Factory. The shoe industry in town declined in the 1920s and 1930s, and the building was likely abandoned during this time. This shoe shop was located on Wight Street. In the 1950s, it was utilized as part of Regis Tannery. (Courtesy of the Raymond Historical Society.)

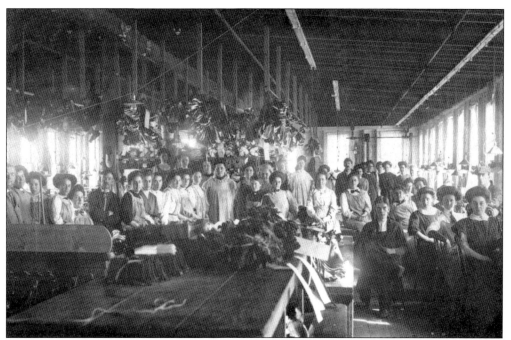

INSIDE SHOE SHOP. This photograph was taken inside one of the town's shoe shops, probably around the beginning of the 20th century. (Courtesy of the Steve Goldthwaite collection.)

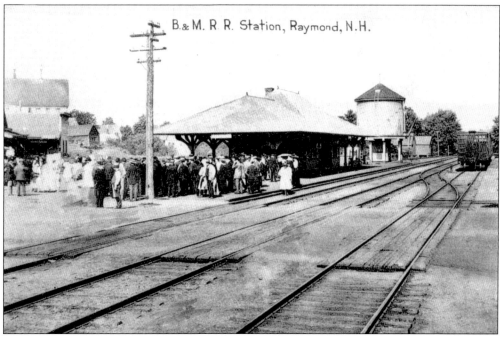

DEPOT FROM TRACKS. This photograph, taken from Main Street, shows the third and current train depot. This depot was built following the devastating 1892 fire. (Courtesy of Joyce Wood.)

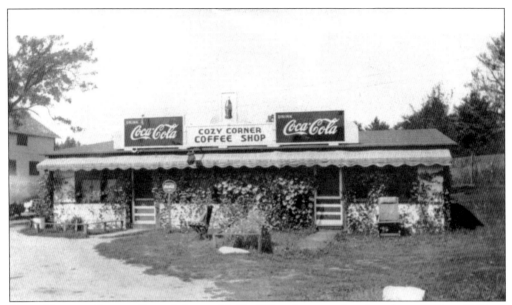

COZY CORNER COFFEE SHOP. John and Lillie Wheadon ran this shop from 1938 to 1949 on the corner of Route 27 and Route 156, where the Cozy Corners Plaza is now. (Courtesy of the Raymond Historical Society.)

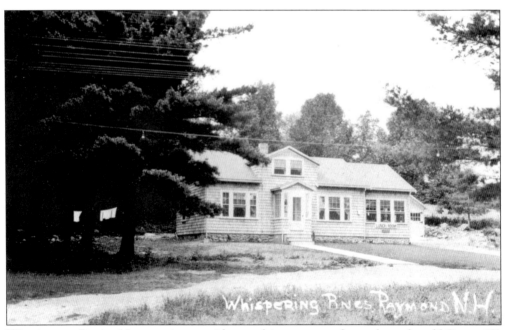

WHISPERING PINES. Now a private residence, this restaurant located on the old Route 101 was once owned by Edgar Trulls and run by Charles and Annamae Stickey during the 1940s. (Courtesy of Joyce Wood.)

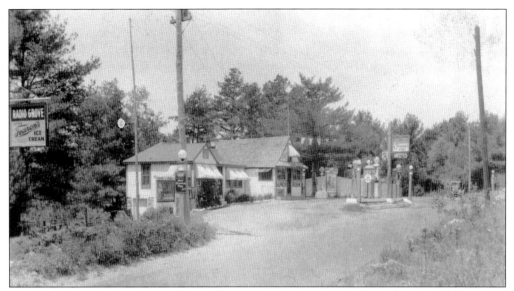

RADIO GROVE RESTAURANT. The Radio Grove Restaurant served good food and featured a large outdoor radio speaker that could be heard for miles. Its chicken a la king and french fries were its specialties. It was owned and run by the Charlie Vergos family from New Jersey starting in the 1940s. It was also a favorite ice-cream stop for many Manchester residents on their way to Hampton Beach via the old Route 101. (Courtesy of the Steve Goldthwaite collection.)

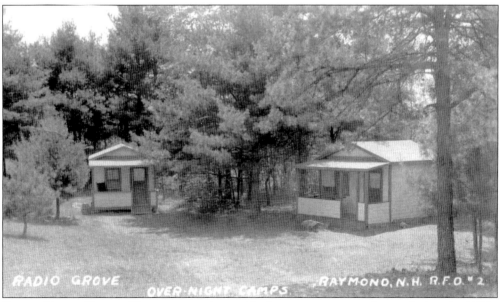

RADIO GROVE CAMPS. These camps, along with the restaurant, were in use during the 1940s. (Courtesy of Joyce Wood.)

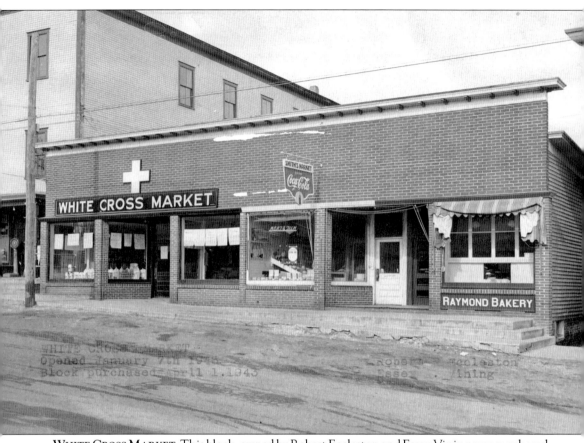

WHITE CROSS MARKET. This block, owned by Robert Eccleston and Essex Vining, was purchased in 1943 and was located on the east side of Main Street. The Raymond Bakery was known for its superb doughnuts and pastries, made fresh each day by Joseph Walters, who was known as Joe the Baker. (Courtesy of the Raymond Historical Society.)

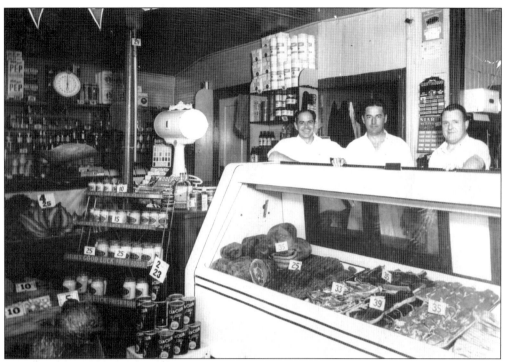

WHITE CROSS MARKET WORKERS. From left to right, Essex Vining, Alfred Gosselin, and Carl Cate are seen inside the White Cross Market. (Courtesy of the Raymond Historical Society.)

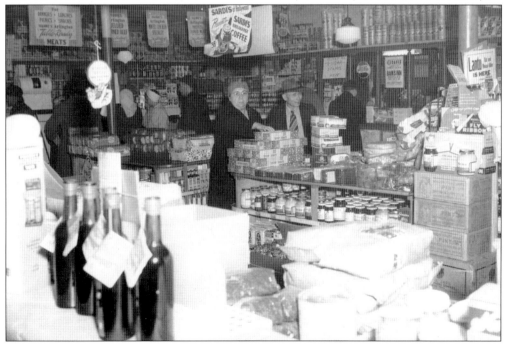

INSIDE THE WHITE CROSS MARKET. In this c. 1946 photograph, Verta McGall and an unidentified man are shopping inside the White Cross Market after it was remodeled. (Courtesy of the Raymond Historical Society.)

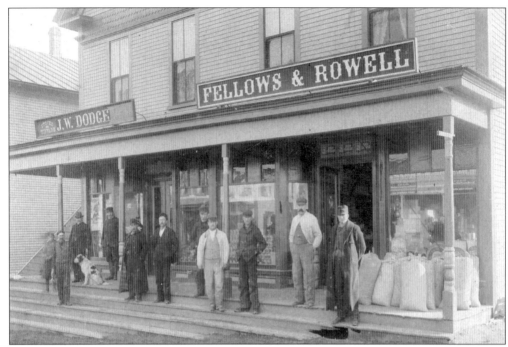

FRUIT STORE, C. 1900. These two shops were located on the west side of Main Street. This building went through many owners and many identities before becoming the Raymond Fruit Store, which burned down in 1998. (Courtesy of the Raymond Historical Society.)

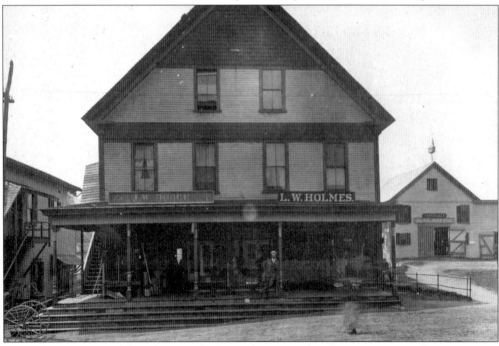

FRUIT STORE, 1907. This photograph shows the west side of Main Street with Jones Livery and Undertaking seen on the far right. Lewis W. Holmes was the father of Iber Holmes Gove. (Courtesy of the Raymond Historical Society.)

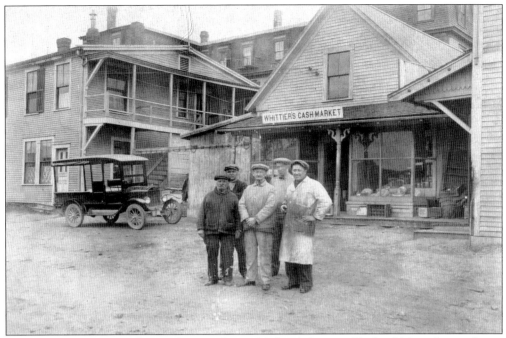

WHITTIER'S MARKET. This market was located behind the east block of Main Street, facing the train depot. This photograph was taken in the early 1900s. (Courtesy of the Raymond Historical Society.)

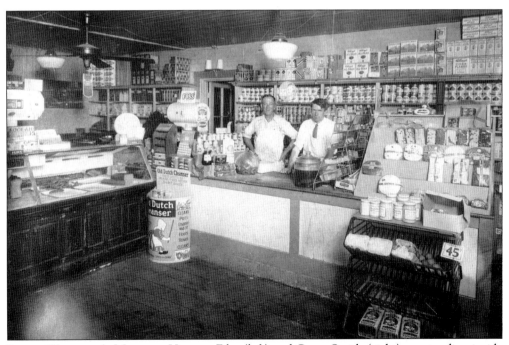

INSIDE WHITTIER'S MARKET. Herman Files (left) and Cyrus Smith (right) are standing inside the Whittier Market during the 1930s. (Courtesy of the Raymond Historical Society.)

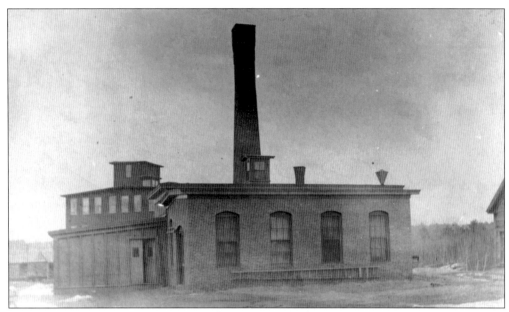

ELECTRIC PLANT. Twenty-seven-year-old Charles Fox built the power-generating plant off Main Street in 1897 and ran it as an independent supplier of electricity for 10 years. In 1898, the first electric streetlamps were put into operation with the help of Fox. (Courtesy of the Raymond Historical Society.)

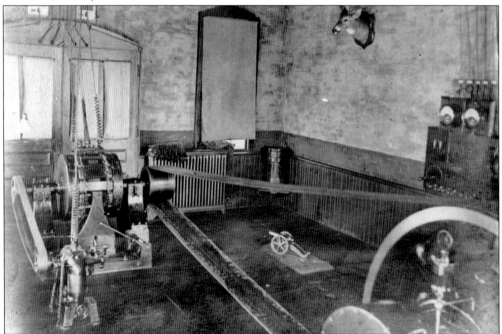

INSIDE THE ELECTRIC PLANT. The miniature cannon in the picture was given to George Guptill Jr. by the Fox family. This cannon was set off yearly at the generating plant at midnight on July 4. After each use, it was placed back in the generating plant. For the past few years, it has been used to signal the start of the town parade. It resides today in the home of Guptill's daughter, Sally Paradis. (Courtesy of Sally Guptill Paradis.)

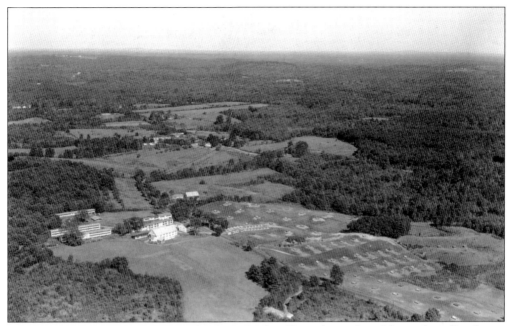

GOVE POULTRY FARM, C. 1946. The Gove Poultry Farm, located on Nottingham Road, was one of the more successful chicken farms in town. Originally owned and operated by George C. Gove, most of the larger buildings can still be seen on Route 156. This farm is now a private residence. (Courtesy of the Raymond Historical Society.)

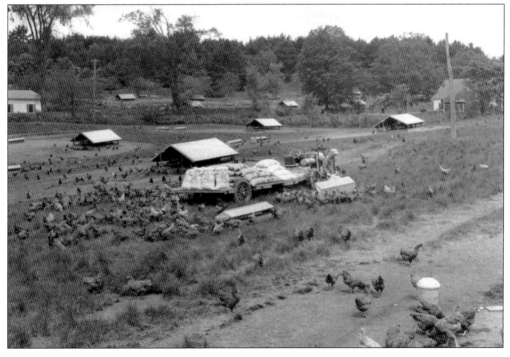

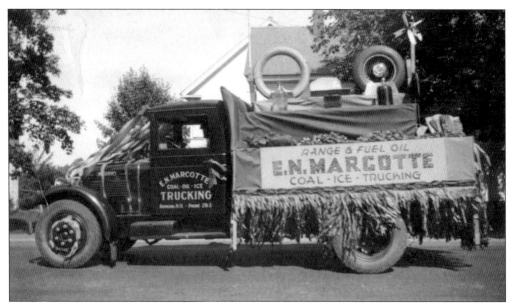

LABOR DAY PARADE, 1935. Eli Marcotte not only ran an ice business in the winter on the Lamprey River, but he also sold coal and oil year-round in his downtown store. (Courtesy of the Raymond Historical Society.)

PRESCOTT FARMS. The Raymond Shopping Center was built during the 1970s, and Ben Franklin is the only remaining original store. (Courtesy of the Raymond Historical Society.)

INSIDE HOLT'S DEPARTMENT STORE. Walter and Thelma Holt came to Raymond from Pennsylvania in 1937 and opened a Ben Franklin store where the senior center on Main Street is today. Quickly after, they rented space in the Independent Order of Odd Fellows (IOOF) building from the Blake family, and the Blakes in turn moved their store around the corner onto Church Street. Eventually they renamed Ben Franklin to Holt's Department Store, which remained in business until the 1970s. Pictured here is owner Thelma Holt (left) and longtime employee Sarah Porter (right). (Courtesy of Shirley Holt Dodge.)

REGIS TANNERY. A new, modern leather-tanning plant was built on Wight Street near the Falconer and Feely Shoe Factory. The tannery was owned by a family originally from Peabody, Massachusetts. Bought in 1953, construction began in 1954 on a new building. With 135 employees at its peak, the plant had its own union and donated funds for new a ambulance. It caught fire in July 1972, after new wiring was installed. It was not rebuilt. (Courtesy of the Raymond Historical Society.)

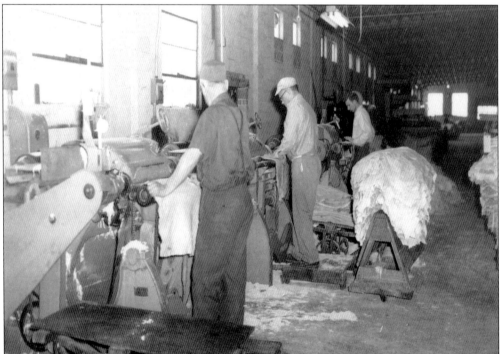

ALUM BATH AT REGIS. Picture here are workers giving the hides an alum bath. (Courtesy of the Raymond Historical Society.)

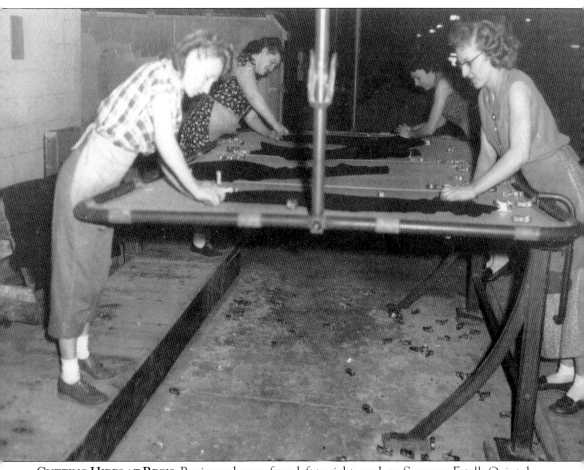

CUTTING HIDES AT REGIS. Regis employees, from left to right, are Jean Sweeney, Estelle Quintal, Jean Brown Downing, and Joyce Taylor Brown. (Courtesy of the Raymond Historical Society.)

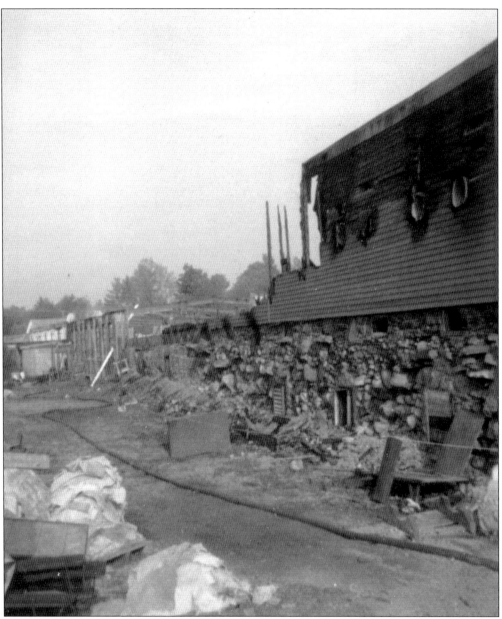

REGIS AFTER FIRE, 1972. Fire departments from 36 area communities fought the huge fire, which engulfed the entire 550-foot-long building within 35 minutes. Smoke from the fire could be seen from the Piscataqua River bridge in Portsmouth. There were propane explosions, and the sprinklers collapsed because the water main was damaged. (Courtesy of the Raymond Historical Society.)

Three

ORGANIZATIONS, ASSOCIATIONS, AND INSTITUTIONS

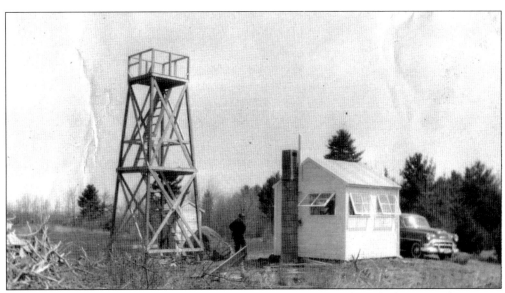

WORLD WAR II LOOKOUT. This was a World War II enemy plane lookout watchtower on Harriman Hill Road, with a civil defense building next to it. This building was donated by the Town of Raymond to Raymond High School (RHS) in 1991. The building, now at the historical society, is used for storage. (Courtesy of the Raymond Historical Society.)

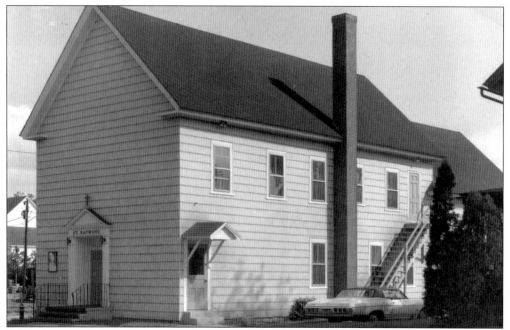

CATHOLIC CHURCH. In 1944, this building was dedicated St. Raymond of Penaford, after a Dominican theologian from the Middle Ages. Father Vaccarest was the first priest. Louis Hamel gifted the land and building to the Catholic Church. Previously a shop and a post office, this building was built in 1890. (Courtesy of the Raymond Historical Society.)

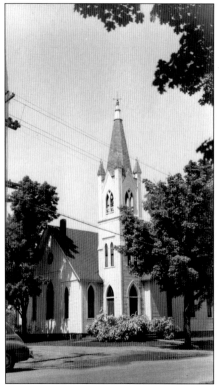

METHODIST CHURCH. After the first Methodist church near the train depot was destroyed by the great fire of 1892, the current structure was built on the corner of Wight and Main Streets in 1894. (Courtesy of the Dudley-Tucker Library.)

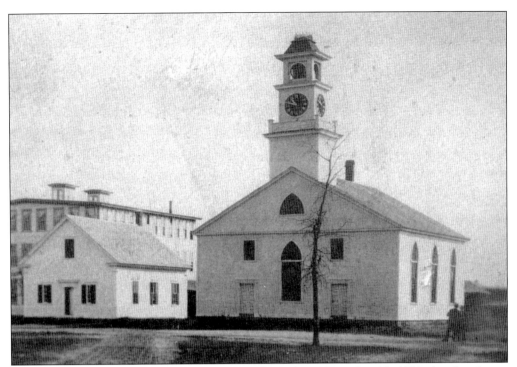

CONGREGATIONAL CHURCH BEFORE FIRE. Dedicated on November 12, 1834, the church was built on the common on land donated by the Blake family. It burned in the great fire of 1892, and a new church was dedicated on March 7, 1894, on the same land. Albert H. Thompson, who became pastor in 1888, helped the church rebuild nearly debt free. (Courtesy of the Raymond Historical Society.)

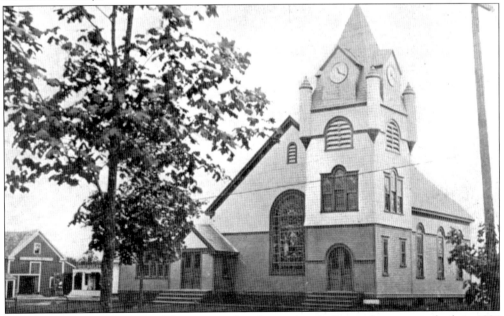

CONGREGATIONAL CHURCH. The current church remains similar to the structure built in 1894 and houses the town clock. (Courtesy of Joyce Wood.)

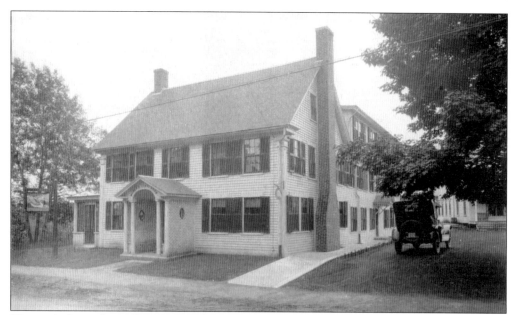

WOMEN'S CIVIC CLUB. In operation from 1922 to 1970, the Falconer family bought the Langford Hotel and Mrs. Falconer rented rooms to the Women's Civic Club. F. W. Falconer spent many thousands of dollars fixing up and refurnishing the 13 guest rooms. He presented it to the club in 1922 with the understanding that it would always be used as a clubhouse for women. The civic club was forced to sell the building after the costs of upkeep were too much. (Courtesy of Joyce Wood.)

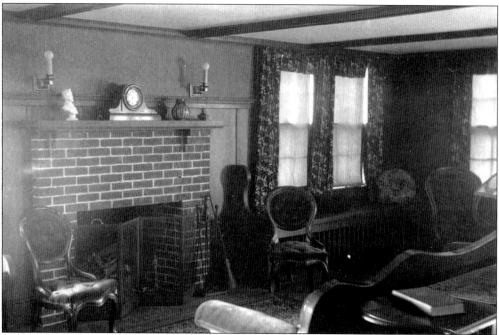

CIVIC CLUB LIVING ROOM. This view shows the living room. (Courtesy of the Steve Goldthwaite collection.)

CIVIC CLUB DINING ROOM. This photograph shows the dining room. (Courtesy of the Raymond Historical Society.)

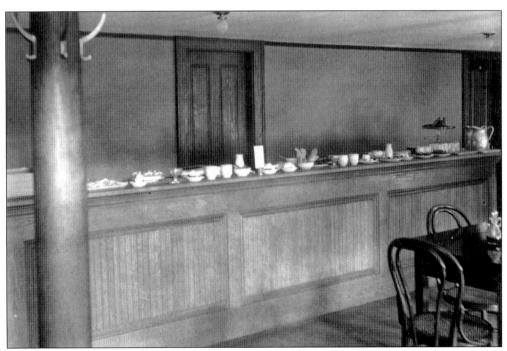

CIVIC CLUB CAFETERIA. This photograph shows the cafeteria at the rear of the hotel where a la carte service was found. (Courtesy of the Steve Goldthwaite collection.)

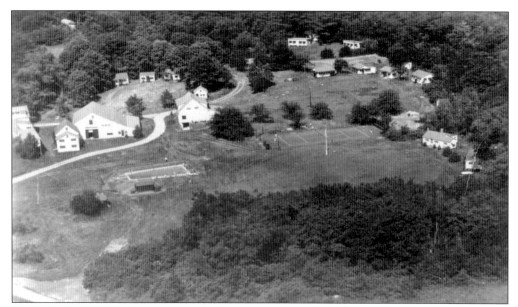

CAMP SE-SA-MA-CA AERIAL VIEW. This camp was open for eight weeks every summer from 1931 to 1982. Mary T. Sargent bought 700 acres on Onway Lake from Charles Brook. Raymond was chosen "because of its accessibility, the warmth of its townspeople and the beauty of this spot along the shadows of Onway Lake." The name of the camp came from the first two letters of Mary and Sargent and also her partner's name, Carolyn Seymour. (Courtesy of the Raymond Historical Society.)

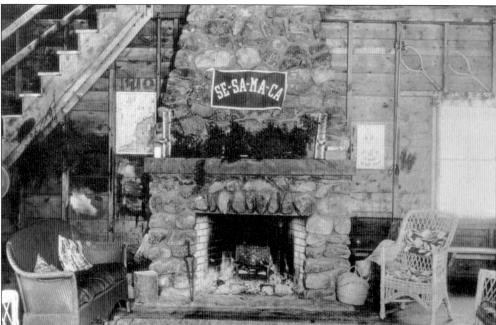

INSIDE VIEW OF SE-SA-MA-CA. The camp was expensive, and most girls came from wealthy families. Some girls came from as far away as the Dominican Republic, France, and Portugal. The first summer there were 60 girls in attendance, and enrollment peaked at 140. (Courtesy of the Steve Goldthwaite collection.)

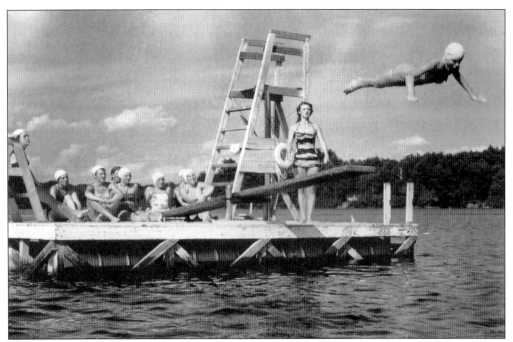

SWIMMING AT CAMP. There was waterskiing, sailing, canoeing, archery, softball, soccer, volleyball, tennis, badminton, swimming, horseback riding, drama, arts and crafts, and dance. Sargent also employed a French chef. (Courtesy of the Raymond Historical Society.)

TENNIS AT CAMP. According to Shirley Jones Barnes's *History of Raymond, NH: 1764–1962*, the "camp is dedicated to the personal growth of campers through gracious living, broadening of interests, individual guidance, acceptance of responsibility, development of talent and skills and accomplishment of goals." (Courtesy of the Raymond Historical Society.)

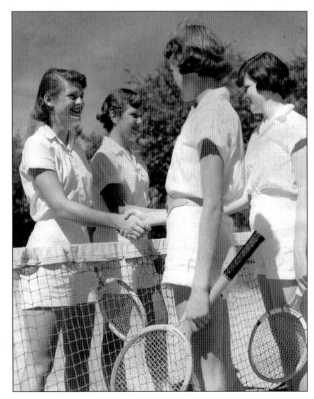

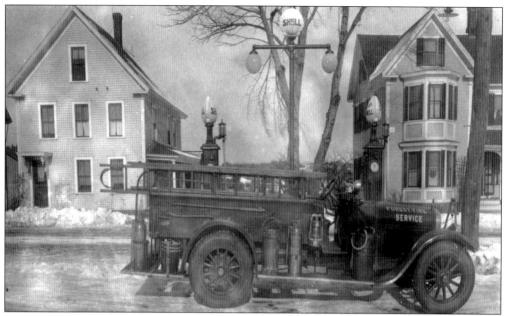

PRIVATELY OWNED FIRE TRUCK. This fire truck was owned by Ray Smith, a 32-year veteran of the fire department, former deputy chief, and fire warden. Smith was the grandfather of the current fire chief, Kevin Pratt. The house on the left was owned by Grover Waterhouse and was built in 1900. The Welch house, on the right, was built in 1880. Both houses are still owned by those families. (Courtesy of the Raymond Historical Society.)

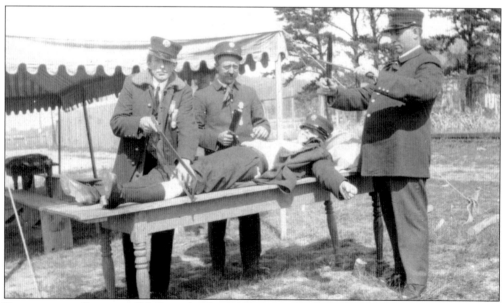

FIREFIGHTERS SURGERY. Ed Cram (with saw), Lewis W. Holmes (with cleaver), Andrew Burke (on table), and Arthur Stokell (knife and steel) are seen here having some fun at a firemen's outing. (Courtesy of the Steve Goldthwaite collection.)

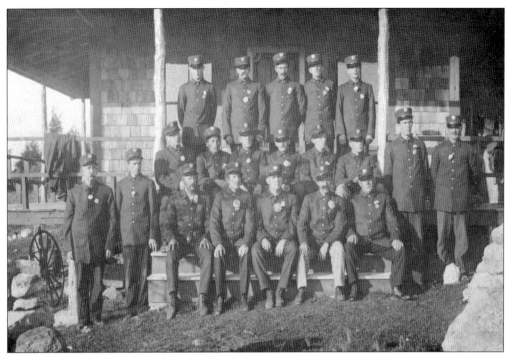

FIREMEN'S OUTING. This firemen's outing on Pawtuckaway Lake took place on September 11, 1910. (Courtesy of the Steve Goldthwaite collection.)

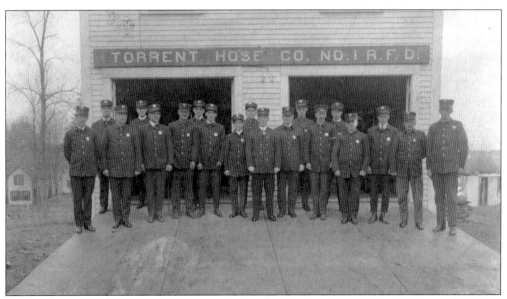

FIREMEN, C. 1917. Pictured from left to right are Arthur Brown, Clark Davis, Horace Whittier, Harry Morrison, Omer "Kid" Vezina, George McClure, Arthur Bean, Walter Sinclair, Leon Fuller, Everett Fellows, Joseph Blake, Clint Conners, Henry Plant, George Purington, Gene Maynard, Louis Gamache, Clarence "Toddy" Clement, Herbert Hartford, and Ed Dudley. The remains of the town hall after its 1917 fire can be seen to the right of picture. (Courtesy of the Steve Goldthwaite collection.)

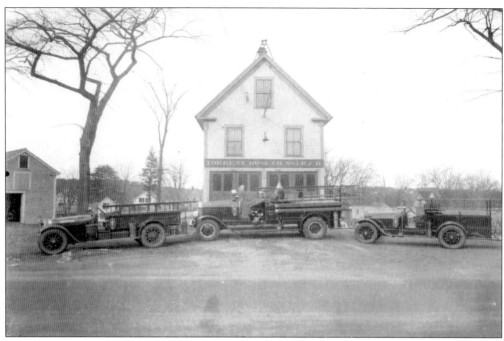

FIRE EQUIPMENT, C. 1930. Raymond's first fire department had only two hose reels. The fire alarm sounded from the shoe factory downtown. Later the first ladder truck was made up of an old hearse pulled by men and then horses. After Raymond gained these new trucks, the department was constantly being called out of town because surrounding towns did not have pumpers. One of these engines is still in use. (Courtesy of the Raymond Historical Society.)

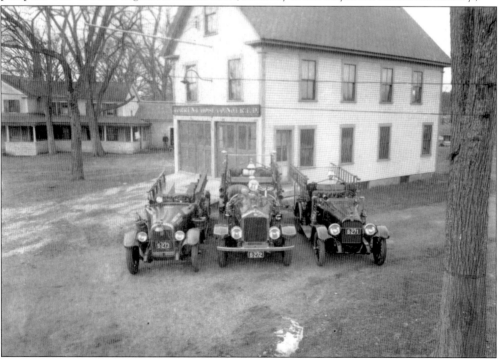

Four
THE 1914 SESQUICENTENNIAL CELEBRATION

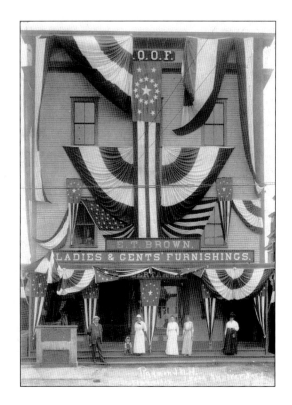

IOOF BUILDING. E. T. Brown was a shopkeeper and also the town undertaker. His building is still standing today on the east side of Main Street and was also Holt's Department Store from the 1940s to 1970s. The IOOF was located on the second floor. (Courtesy of the Raymond Historical Society.)

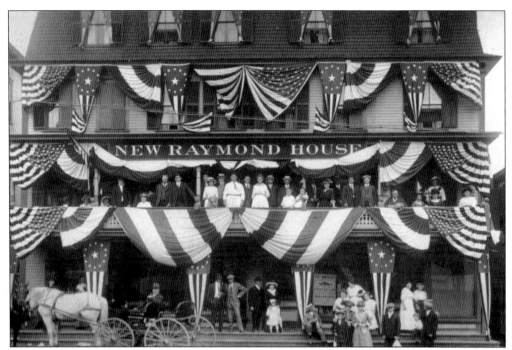

NEW RAYMOND HOUSE HOTEL. The festivities brought out 5,000 people for the town's 150th anniversary celebration. This hotel was located on the east side of Main Street and was destroyed by fire in 1925. (Courtesy of the Raymond Historical Society.)

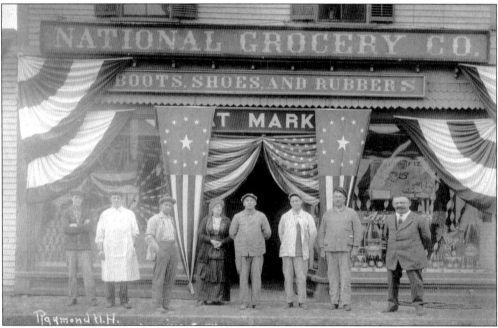

NATIONAL GROCERY. This store was located on the west side of Main Street, directly next to where the Longbranch Restaurant is today. From left to right are Austin Clement, unidentified, John Fellows, Mabel Hill, Ernest Fellows, Jim Clement, Harry Hardy, and Lewis W. Holmes. (Courtesy of the Raymond Historical Society.)

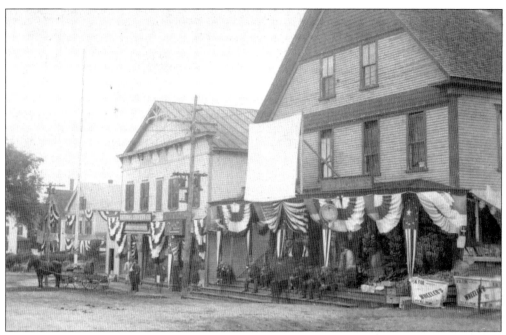

WEST SIDE OF MAIN STREET. The building on the right housed, at any given time, two separate stores. Some businesses sold stoves and dry goods, and others sold fruit and candy. This building burned down on March 28, 1998, and was not rebuilt. (Courtesy of the Steve Goldthwaite collection.)

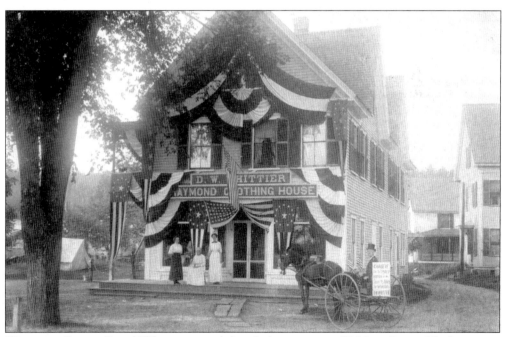

WHITTIER STORE. David Whittier owned this clothing store on 73 Main Street. The home was built in 1900 and is now a four-unit apartment. From 1904 to 1905, Whittier printed the town reports. (Courtesy of the Steve Goldthwaite collection.)

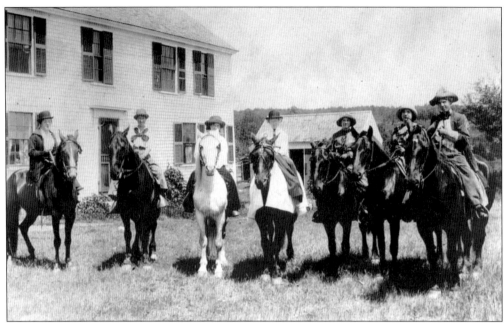

LADY RIDERS. These women on horseback followed the IOOF float in the parade. From left to right are young Nellie Guptill, Lillian Guinea, unidentified, Dorothy Chase Sargent, Mollie McClure, Gladys Langford, and unidentified. (Courtesy of the Steve Goldthwaite collection.)

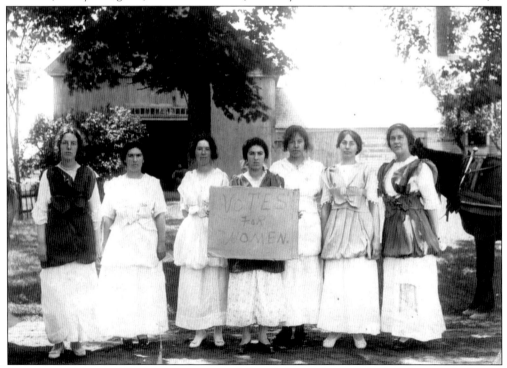

VOTES FOR WOMEN. These women, pictured from left to right, marched in the parade: Jennie Hardy, Olive Tilton, Leona Hardy, Nancy Tilton, Eunice Hardy, Adelle Rand, and Fannie Robie. (Courtesy of the Raymond Historical Society.)

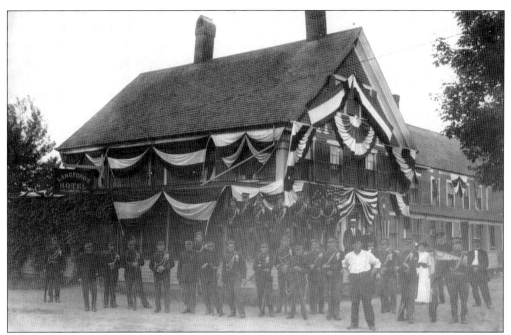

LANGFORD HOTEL. Joe Langford and his wife, Maude, were owners of the Langford Hotel, which today houses the Pilgrim Apartments. This home, built in 1835, was first called the Shepard House, which took in boarders and was popular due to its close proximity to the train depot. In 1970, the hotel, then called the Pilgrim Inn, closed, and it was the last place in town for public overnight accommodations. (Courtesy of the Raymond Historical Society.)

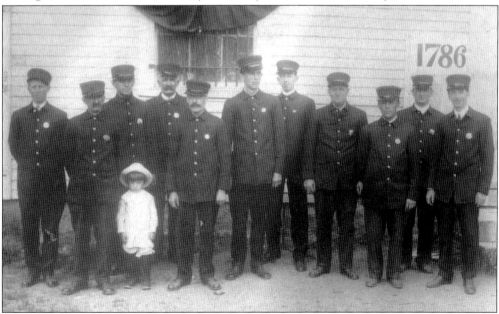

FIREFIGHTERS. These firemen are standing in front of the old town hall. From left to right are Andrew Burke, Al "Ed" Greenleaf, Triffley Brusso, Leslie Brusso, Chase Colcord, Charles Moulton, Ed Dudley, Byron Page, Harry Wormwood, John Fellows, Clark Davis, and Harry Tilton. (Courtesy of the Raymond Historical Society.)

THE DUDLEY-TUCKER LIBRARY. The town library here looks very much as it does today. When this picture was taken, the building had only been standing for six years. In the summer of 2008, the library will celebrate its centennial. (Courtesy of the Steve Goldthwaite collection.)

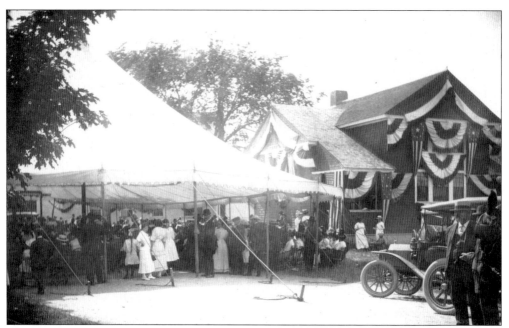

TENT IN FRONT OF LIBRARY. Under this tent was a town meeting of sorts. Selectman Sherburn Gove introduced Gov. Samuel Felker, who delivered the main address of the meeting. The original petition for the town charter and the original deed for the town were read. Rev. A. M. Osgood offered a prayer. There was music and other speeches by Raymond residents. (Courtesy of the Raymond Historical Society.)

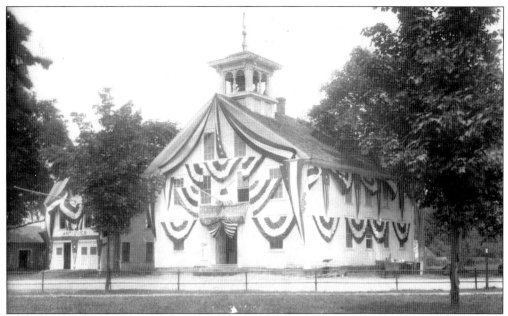

TOWN HALL. This building was at one point located where the current safety complex is, which is the geographic center of town. The hall was dedicated in June 1786. There was a vote taken in 1797 to move the building closer to the center of business. It took more than 120 pairs of oxen to move the building to its location on Epping Street next to the former fire station. (Courtesy of the Raymond Historical Society.)

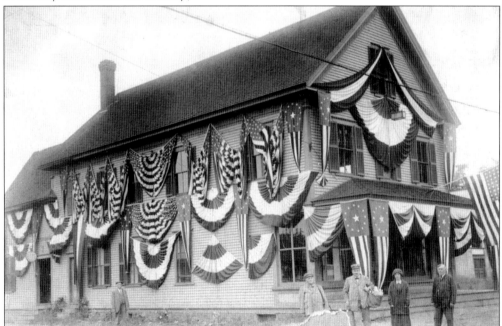

POST OFFICE. From 1914 through 1942, this building housed the town's post office. There was also a clock repair shop out back, and the Chase Chamberlain Shoe Shop Union had offices upstairs. The post office was moved in 1942 to the west side of Main Street. (Courtesy of the Raymond Historical Society.)

DR. GOULD HOME. This house, built in 1848, is located on the corner of Main Street and Old Manchester Road. It was the home of town surgeon True M. Gould, who began his practice in Raymond in 1855. He died in 1904 at the age of 72. His home has since been turned into apartments. (Courtesy of the Raymond Historical Society.)

DR. GUPTILL HOUSE. Dr. George Guptill purchased land at the corner of Main and Moulton Streets and his residence was constructed in 1902. His office was in his home, and a room on the second floor was prepared to house a patient for extended care. The front door still carries traces of the doctors office hours, etched in the glass. (Courtesy of the Steve Goldthwaite collection.)

METHODIST PARSONAGE. This was a house where the Methodist minister and his family would live. Located on Old Manchester Road near Main Street, this home is now apartments. (Courtesy of the Raymond Historical Society.)

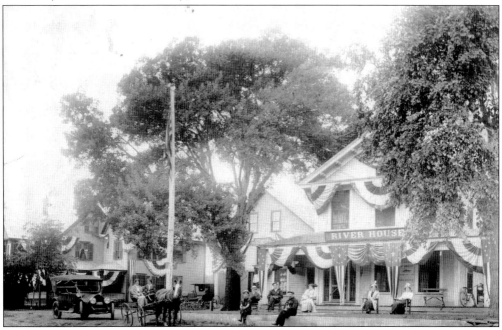

RIVER HOUSE. This was a rooming house with a saloon in the basement. Local businessman Ai Welch's father, Frank Welch, owned and operated the rooming house for a number of years. It was originally built and run as an inn and livery by George and Clara Pecker from 1873 to 1914. It is now a three-family house. (Courtesy of the Raymond Historical Society.)

HOME ON EPPING STREET. This home was built in 1900 and was used as a private residence for some time. Starting in the 1940s, a series of dentists used the home as their office. Dr. Mayo's office was housed there until the mid-1950s, in which time Dr. Dionne came in. Dr. Paul Silver is the present dentist, and at one point in time, Dr. Gary Graham's chiropractic office was located in the basement. Today his office is located near the entrance to Long Hill Road on the old Route 101. (Courtesy of the Raymond Historical Society.)

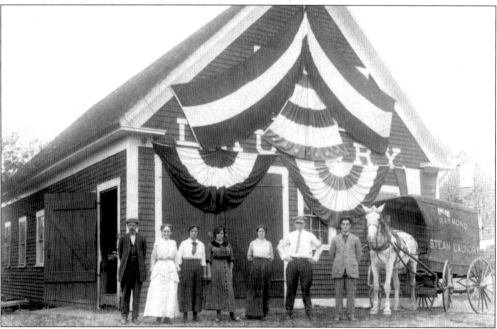

STEAM LAUNDRY. This building housed the town's steam laundry and creamery. It was located on the corner of School Street and Epping Street. There was a disastrous fire in the decade that followed the anniversary celebration, and the building was not rebuilt. (Courtesy of Joyce Wood.)

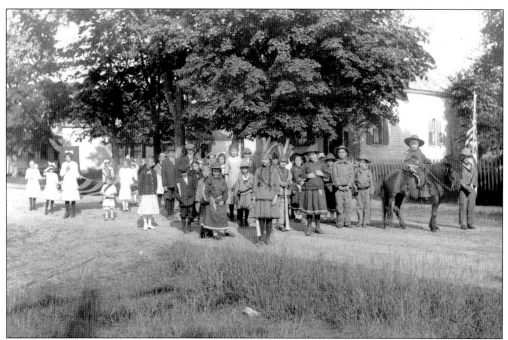

THE HORRIBLES 1914 CELEBRATION. The parade of horribles, as the children were called, was led by "Colonel" George Guptill Jr. The children led the parade and were dressed as cowboys and Native Americans. The group includes Clifton Baker, Dorothy Blake Tilton, Phyllis Rowe, Eldon Houle, Harold Houle, Sherburne Blake, Barbara Cram, Hildergard Shepard, Norma Shepard, Priscilla Sanborn, and Iber Holmes. (Courtesy of the Raymond Historical Society.)

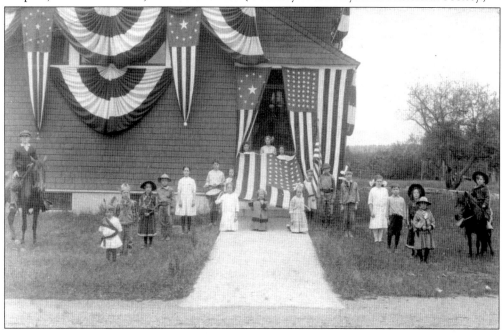

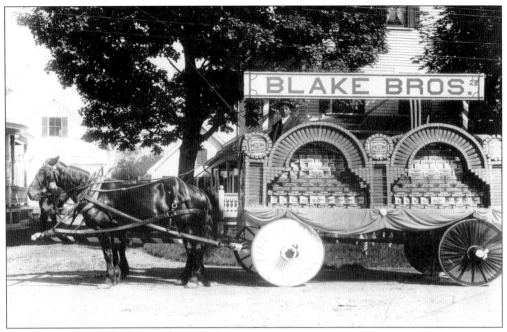

BLAKE FLOAT. The Blake family owned and rented store space on the east side of downtown Main Street to the Holt family to run a Ben Franklin store. In 1936, Mr. Blake moved his store behind Candyland. The Blakes also owned their own dry goods store and this float, where he sold Sunshine Biscuits. (Courtesy of the Raymond Historical Society.)

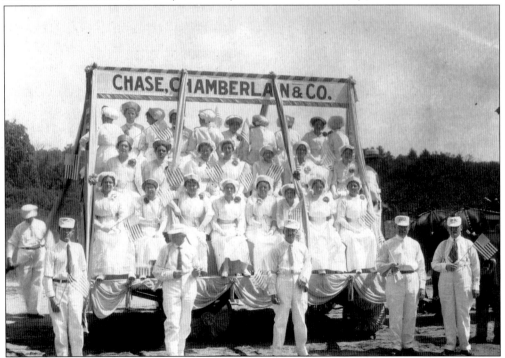

CHASE CHAMBERLAIN FLOAT. These were workers from the Chase Chamberlain factory behind the train depot. (Courtesy of the Raymond Historical Society.)

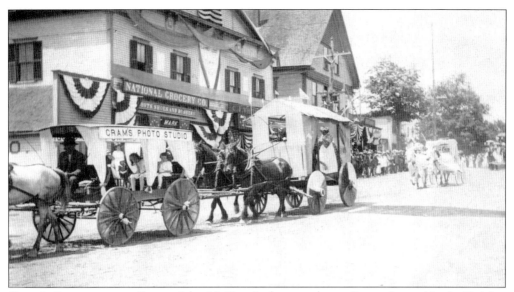

CRAM'S PHOTOGRAPHY FLOAT. John M. Cram's photography studio was located in the Knights of Pythias building on the second floor. The two girls on the float were his daughters Vivian and Barbara. John M. Cram was the son of the town's Civil War hero John E. Cram. (Courtesy of the Steve Goldthwaite collection.)

DODGE-FELLOWS FLOAT. The parade is pictured here passing the current Brewitt Funeral Home. David Fellows and Mattie Dodge were local entertainers who went by the names Joshua and Amanda Gibbons and probably had a variety show at the festivities. (Courtesy of the Steve Goldthwaite collection.)

FALCONER FAMILY. This family owned the shoe factory on Wight Street. The family was very generous with the town. The building to the left is the original post office. (Courtesy of the Steve Goldthwaite collection.)

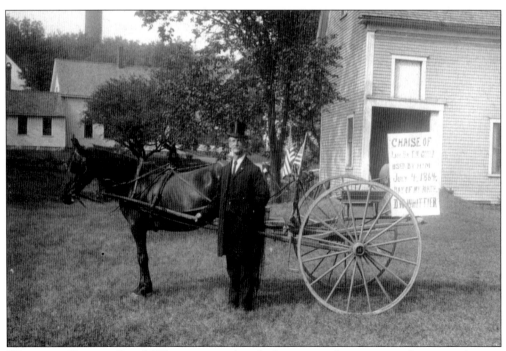

WHITTIER CHAISE. David Whittier owned a clothing store downtown and was a volunteer fireman. The sign on the wagon reads, "Chaise owned by the late Dr. T. M. Gould, used by him July 4, 1864, the day of my birth." (Courtesy of the Steve Goldthwaite collection.)

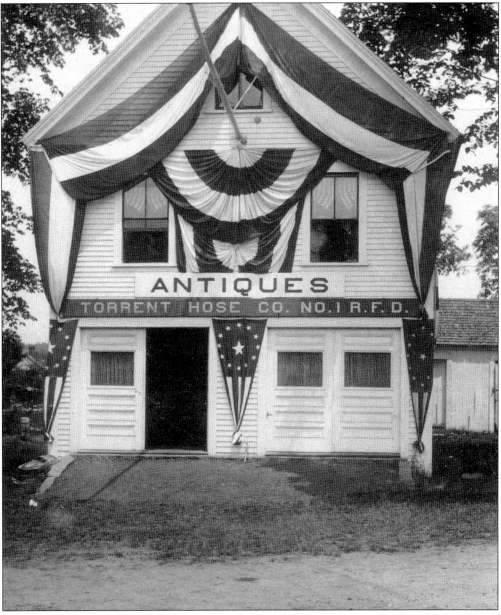

ANTIQUES FOR SALE. The fire department dedicated this building in 1905, and here it is all dressed up for the town's 150th anniversary. (Courtesy of the Steve Goldthwaite collection.)

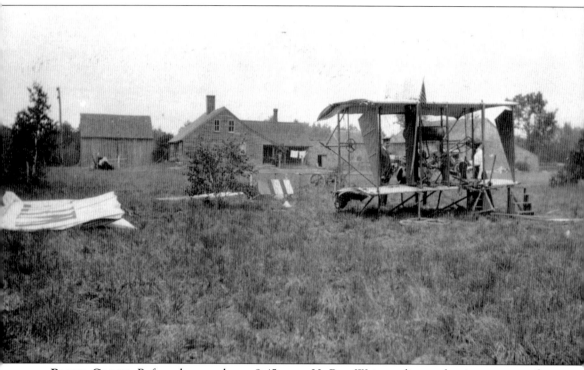

PLANE CRASH. Before the parade, at 9:45 a.m., H. Roy Waite, a licensed aviator, was to fly his Burgess biplane over the town. However, his plane was tipped by a gust of wind at a height of 200 feet and crashed on the Brown farm, near the Fremont line. Waite was uninjured. He came back to Raymond in 1964 for the town's 200th anniversary. (Courtesy of the Steve Goldthwaite collection.)

Five

SCHOOL DAYS

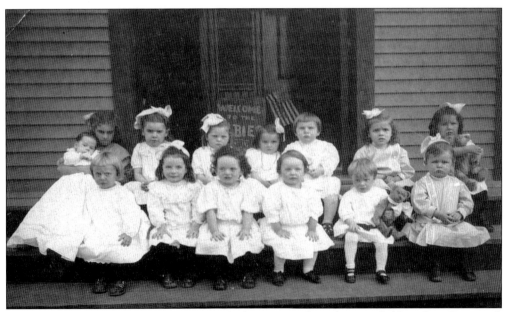

KINDERGARTEN, C. 1908. This photograph shows a number of young children from Raymond. Included in the first row are, from left to right, unidentified, unidentified, Vivian Cram, Barbara Cram, Octavius Fellows, and unidentified. The second row includes Grace Berry, Dorothy Berry, Phyllis Rowe, Norma Shepard, Rosebelle Gordon, and Iber Holmes. (Courtesy of the Raymond Historical Society.)

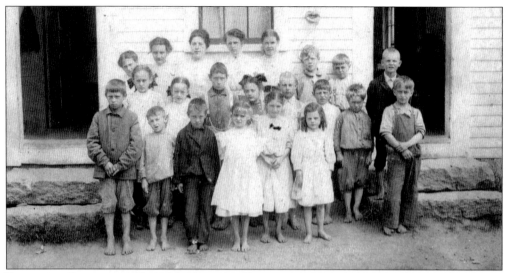

FREETOWN SCHOOL, 1905–1906. This schoolhouse was on Batchelder Road, near Old Chester Road and Fremont Road. (Courtesy of the Raymond Historical Society.)

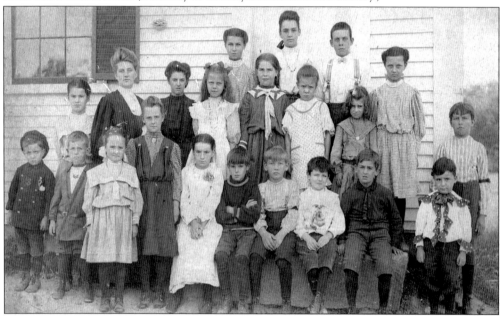

GILE SCHOOL, 1906. This school was built in 1855 and closed in 1916, when all the one-room village schoolhouses were being incorporated into the new consolidated school. The Gile School was located on the corner of Old Manchester Road and Scribner Road. The building was later moved downtown near the railroad station and used as a store. Norris Gove purchased it and gave it to the Congregational Church in 1973. It was moved in 1981 behind the railroad depot when it was bought by the historical society. Pictured are (first row) John Allen, George Gove, Eva Dearborn, Grace Dearborn, Lottie Raymond, Guy Berry, Harry MacFarlane, Nelson Wheat, Arthur Moody, and Alfred Raymond; (second row) Laura Raymond, Arvilla "Babe" Thompson, May Moody, Mattie Hammond, Vialetta Brown, Myrtle Allen, Grace Berry, Lillian "Alice" Guinea, and Fred McFarlane; (third row) Etta Guinea, Lulu Raymond, and Harry Brown. (Courtesy of the Raymond Historical Society.)

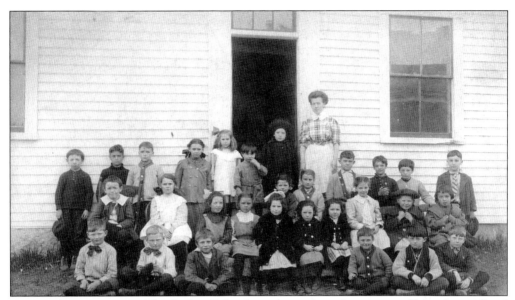

PECKER SCHOOL, 1910. The Pecker School was located on the corner of Manchester Road (Main Street) and Harriman Road. It had two rooms; primary classes were in the rear, grammar in the front room. This was also called the primary and grammar school. (Courtesy of the Raymond Historical Society.)

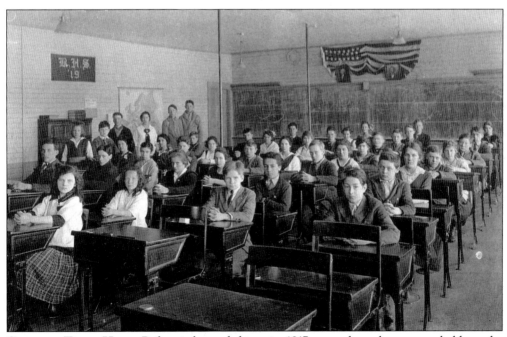

CLASS IN TOWN HALL. Before it burned down in 1917, secondary classes were held on the second floor of the town hall. (Courtesy of the Raymond Historical Society.)

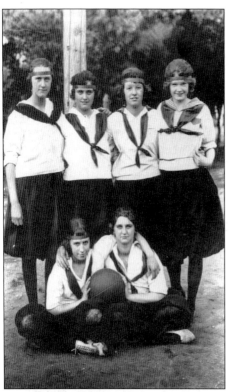

RHS GIRLS BASKETBALL, 1922. Pictured in this photograph are Ruby Folsom, Margaret Armstrong, Pearl Hardy, Elise Pond, Priscilla Sanborn, and Pauline York. (Courtesy of the Raymond Historical Society.)

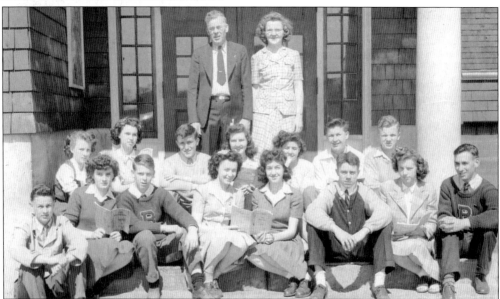

RHS PYNECONE STAFF, 1944. The *Pynecone* is the yearbook for RHS, and this was the 1944 yearbook staff. From left to right are (first row) Reed Carver, Jacqueline Lyman, Stanley Shepard, Charlena Thompson, Louise Davis, William Peaslee, Maxine Carver, and Delma Langille; (second row) Sylvia Moulton, Barbara Tuffy, Robert Cammett, Alice Purington, Audrey Mafera, Carlton Paquette, and Hughin Holt; (third row) principal Webster White and teacher Winifred Small. (Courtesy of Joyce Wood.)

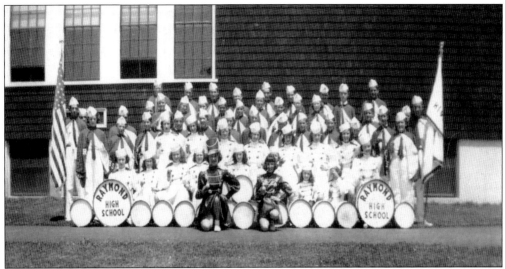

RHS Drum and Bugle Corps. This c. 1952 photograph shows the RHS band, which had a very large portion of the student population among its ranks. (Courtesy of the Raymond Historical Society.)

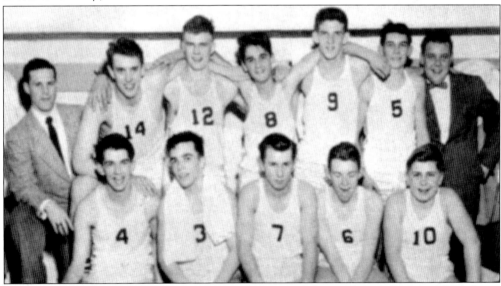

RHS Championship Basketball Team, 1955. From left to right are (first row) Mel Cross, Carroll Dudley, Bob Dickinson, John Frost, and Dick Robinson; (second row) coach Bill Hixon, Gege Reynolds, Romeo Levesque, James Downing, Dave Lyons, Jim McBride, and manager Neal Welch. The five seniors, Reynolds, Levesque, Cross, Dudley, and Downing, had been playing basketball together since the age of nine, under the guidance of school principal John Callaghan. The boys would practice with Callaghan every Sunday in the gymnasium. The team petitioned the New Hampshire Interscholastic Athletic Association to join class B (the school belonged to class C due to its small size). Even though Raymond would play teams from schools two and three times bigger than RHS, the team was not content to compete in class C. According to fellow student Sally Guptill Paradis, the team was known far and wide as a "Cinderella team," and it remains, to this date, the only RHS basketball team to win a state championship. (Courtesy of Sally Guptill Paradis.)

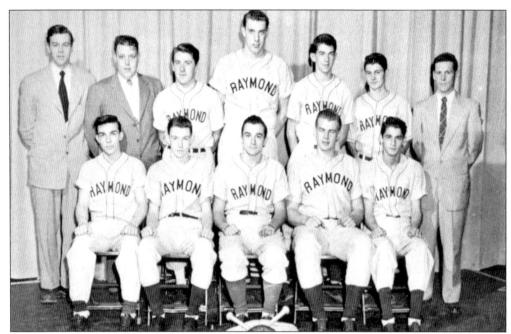

RHS Championship Baseball Team, 1955. From left to right are (first row) Carroll Dudley, John Frost, Steve Menard, Romeo Levesque, and James Downing; (second row) assistant coach Mixon, Neal Welch, Richard Lessard, George Reynolds, Melvin Cross, Jack Towle, and head coach Bill Hixon. (Courtesy of Alison Welch Lacasse.)

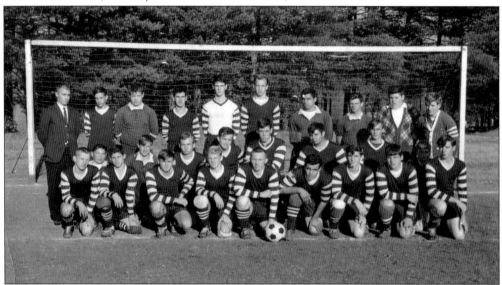

RHS Championship Soccer Team, 1965. This soccer team won the state championship in 1965. Pictured from left to right are (first row) David Fernald, Mike Foley, Charles Proulx, Kerry Clock, John Fernald Jr., Nick Cenatiempo, Dennis Campbell, Peter Happny, and Hayden Noel; (second row) Greg MacIntosh, unidentified, Dave Irwin, Andy Maloney, John Reece, Mike Pettengill, Donald Tilton, and unidentified; (third row) coach Lee Mason, Wayne Bailey, Ron Brown, Jake Cammett, Joe Downing, Bob Thistle, Ralph Cenatiempo, unidentified, Chris Mataragas, and unidentified. (Courtesy of the Raymond Historical Society.)

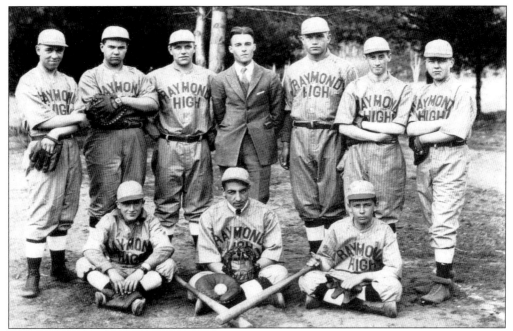

EARLY RHS BASEBALL TEAM, c. 1920. From left to right are (first row) George Guptill Jr., Eldon Houle, and unidentified; (second row) Wilmer Baker, Jim Garland, Cliff Baker, Wesley Smith (teacher), Bill Roberts, and two unidentified members. (Courtesy of the Raymond Historical Society.)

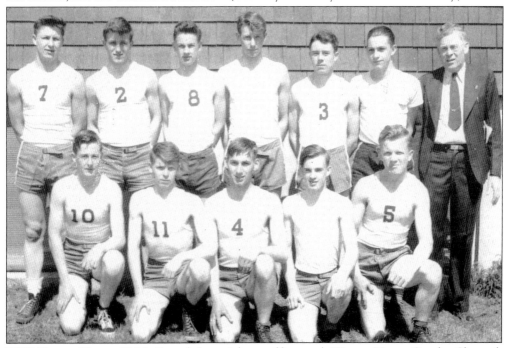

RHS TRACK TEAM, 1944. From left to right are (first row) Warren Noyes, Stanley Shepard, Delma Langilee, Frank Guyette, and Hughin Holt; (second row) Carlton Paquette, Robert Cammett, Reed Carver, Edward Moulton, William Peaslee, Carl Cate, and principal and coach Webster White. (Courtesy of Joyce Wood.)

81

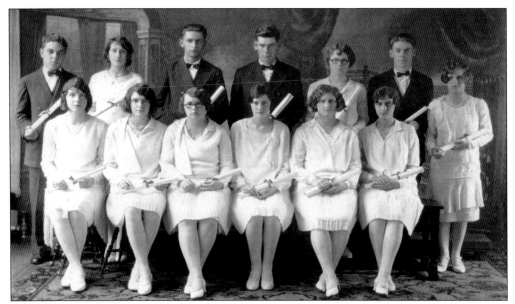

RHS Class of 1928. From left to right are (first row) Lily Quimby, Marion Nickels, Hazel Dudley Littlefield, Doris Clement Robbins, Muriel Littlefield Proctor, Lahoma McQueston, and Louise Damory; (second row) Arthur Varnum, Marguerite Brown, Lloyd Rollins, Theodore Blanchard, Mary Mitchell Baker, and Everett Pitman. As of this writing, Doris Clement Robbins is the oldest living RHS alumnus. (Courtesy of the Raymond Historical Society.)

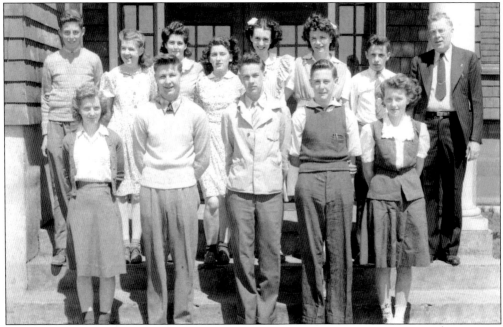

RHS Class of 1946. This photograph was taken in front of the old Iber Holmes Gove Middle School. From left to right are (first row) Georgia Hills, Carlton Paquette, Reed Carver, Warren Noyes, and Sylvia Moulton; (second row) unidentified, Marilyn Titus, Betty Bearisto, Wanda Lyman, Annette Tuffy, Rita Tetreault, Robert Rioux, and principal Webster White. (Courtesy of Joyce Wood.)

LAMPREY RIVER ELEMENTARY SCHOOL, 1976. The elementary school, still in use, was built in 1976 to accommodate grades 1–6. Because of rapid growth, grades 5 and 6 were soon housed at the middle school. A new, modern structure was added in 2005 to house the first public kindergarten in Raymond. (Courtesy of the Raymond Historical Society.)

ORIGINAL RHS BEING BUILT, 1918. The consolidated school, first known as the Stephen K. Batchelder School because he donated the land, is shown here in its early building stages. It was completed in January 1918 and cost less than $20,000 to build. The school was situated with a view of the river and the mountains and away from the distracting influence of the streets and stores. It was the first school in the region that was consolidated. (Courtesy of the Raymond Historical Society.)

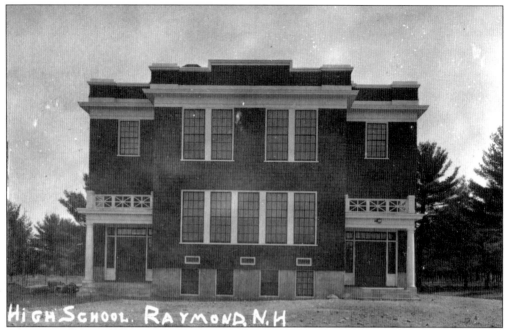

RAYMOND CONSOLIDATED SCHOOL, 1918. This is the original structure of the Raymond Consolidated School. There were four graduates in the class of 1918: Ai Welch, Rodney Hardy, Andrew Gordon, and Lillian Brackett. This building had eight rooms and 20 pupils when it was first built. (Courtesy of the Raymond Historical Society.)

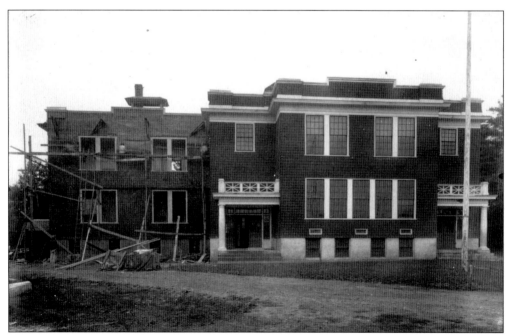

RHS FIRST ADDITION, 1931. This picture depicts the first addition to the Raymond Consolidated School. The cafeteria was housed in the basement. (Courtesy of the Raymond Historical Society.)

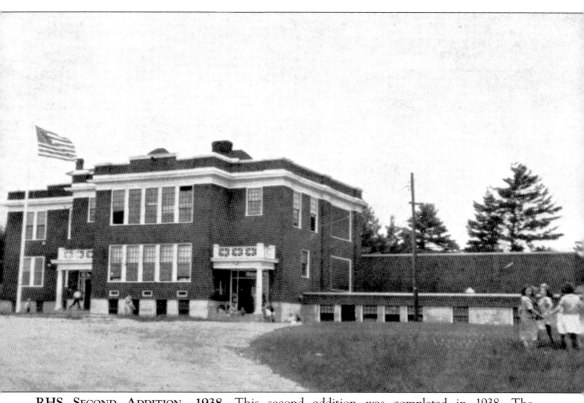

RHS Second Addition, 1938. This second addition was completed in 1938. The gymnasium/auditorium is located to the back and right of the building. (Courtesy of Joyce Wood.)

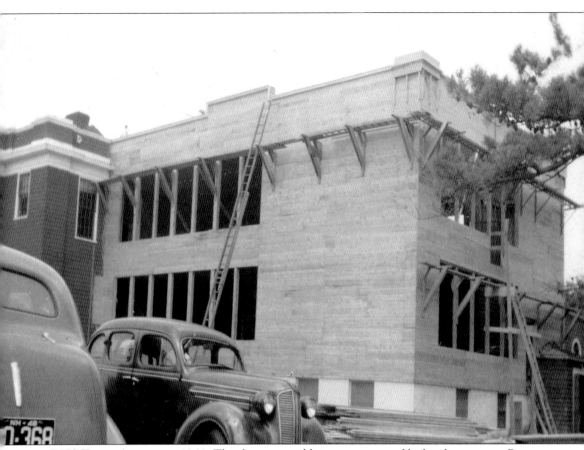

RHS Third Addition, 1948. This four-room addition, constructed by local carpenters Burgess and Carl Chase, was completed in 1948. By 1952, there were 80 students, and by 1961, there were 152 students. There would be more structural changes and portable classrooms added on until this school, later known as the Iber Holmes Gove Middle School, was torn down to make way for a modern school in 2006. (Courtesy of the Raymond Historical Society.)

Six
HOMES, INNS, AND TAVERNS

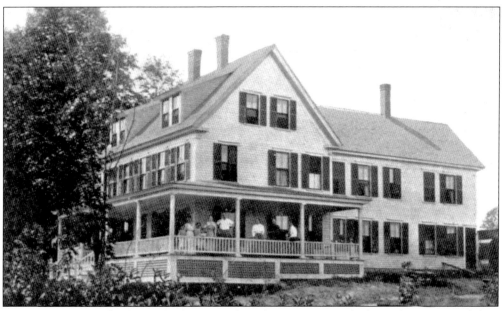

LAKEVIEW FARM. This home, built in 1908 by Ed Berry, was run by his wife, Bessie, and then by their daughter, Grace Kimmel. It was a summer boardinghouse located at 59 Onway Lake Road. The owners provided meals, specializing in baked bean suppers on Saturday night and a full-course chicken dinner on Sunday, which were attended by visitors and townspeople. It stopped being used as an inn after World War II. Today it is a private residence. (Courtesy of Joyce Wood.)

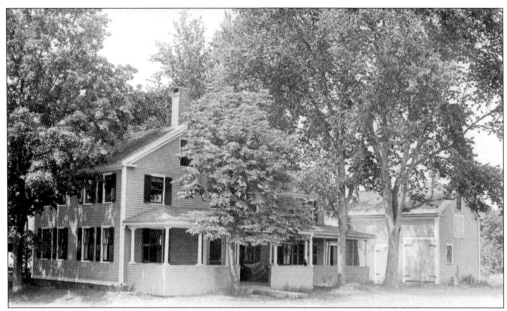

CONGREGATIONAL PARSONAGE. This home was built in 1834 on land given by the Blake family beside the old meetinghouse. It was sold in 1972 to the Brewitt brothers of Epping, who still own the building and run it as a funeral home. A new parsonage was built on Juanita Avenue on land donated by Assunta Ege and Frances Spinazzola. (Courtesy of Joyce Wood.)

GILE HOME. Built in 1850 on 50 acres, the old Martin Gile home is located on Old Batchelder Road (today 5 Gile Road). The Gile school building can be seen under the tree at the right of this view on its original site. At one point, this was Joseph Mandile's poultry farm. It was also James and Blanche Clement's poultry farm from the 1930s to mid-1940s. This was just one of many chicken farms in Raymond at the time. (Courtesy of the Raymond Historical Society.)

HOUSE ON OLD MANCHESTER ROAD, 1902. This photograph shows Mabel (Kendall) Fellows at age 16. This home, located at 16 Old Manchester Road, is on the corner of Wight Street. (Courtesy of the Raymond Historical Society.)

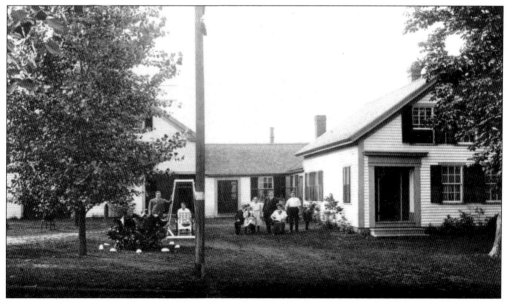

SINCLAIR HOUSE. The home of David Sinclair, the railroad superintendent, was located on 32 Epping Street near the exit from the middle school. Built in 1900, this photograph was taken on July 11, 1912. (Courtesy of the Raymond Historical Society.)

THE BEAN TAVERN. This is the oldest house in Raymond. The first town meeting was held here on May 29, 1764. Eventually the meetings were held closer to the businesses in town, but the men preferred to meet here due to the fact that they could enjoy rum. The tavern continued to be used for town meetings until 1785, when the new town hall was built. It was also used as a house of worship before the churches were built in town. (Above, courtesy of Peg Louis; below, courtesy of the Raymond Historical Society.)

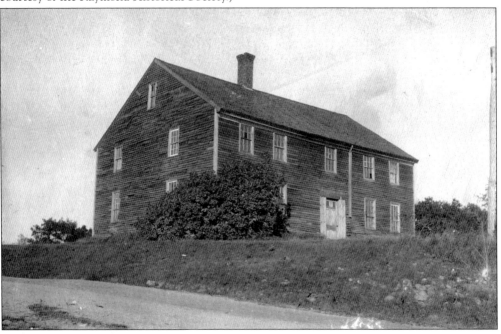

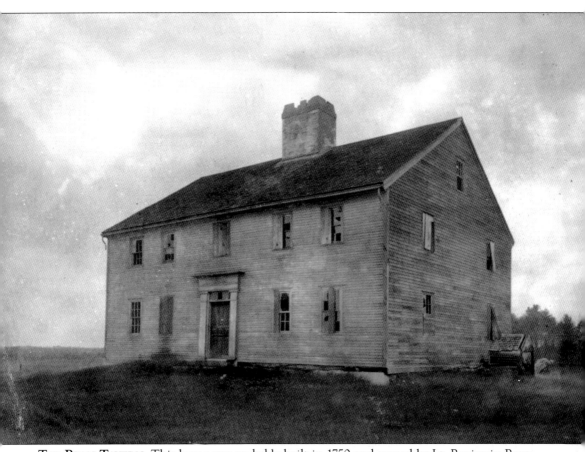

THE BEAN TAVERN. This home was probably built in 1750 and owned by Lt. Benjamin Bean. His son Thomas continued to run the tavern after Bean's death in 1804. It was given up shortly after. Today it is a private residence, and the owners continue to attempt to maintain the antique integrity of the house. (Courtesy of Peg Louis.)

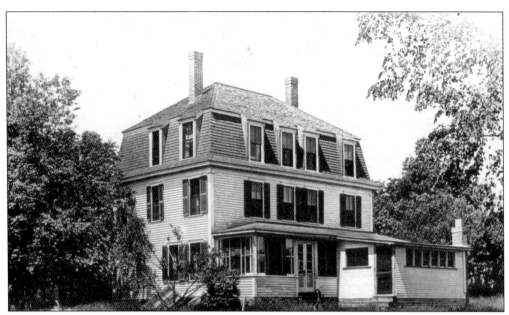

Onway Lake House. Built in 1910, this home was once the Moody Farm, located at 61 Onway Lake Road. It also took in summer boarders who came to take advantage of the great lake access. (Courtesy of the Steve Goldthwaite collection.)

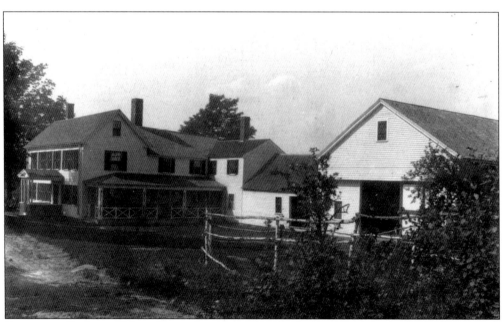

Roxmont. Built in 1850 and once known as the Dooley Farm, this home probably took in summer boarders of Onway Lake. It is now a private residence. (Courtesy of Joyce Wood.)

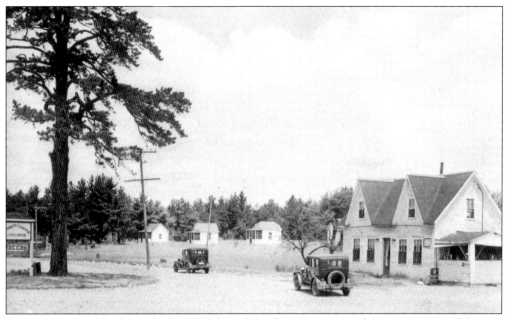

SUNSET CAMPS. Harold and Mary Welch and daughter Emma ran this restaurant, well known for its good food and homelike atmosphere, on the old Route 101. In addition to the restaurant, there were overnight camps, a gas station with garage, and a swimming pool. The camps were in operation in the 1930s and 1940s. (Courtesy of the Steve Goldthwaite collection.)

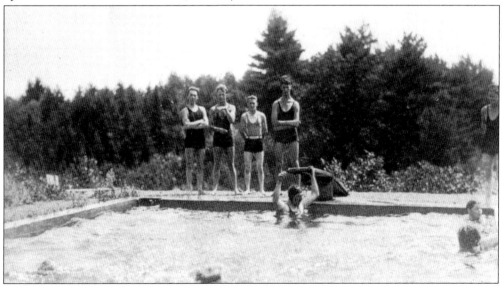

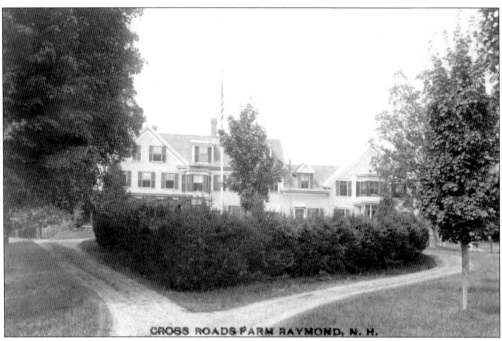

CROSS ROADS FARM. Located on Chester Road, this private residence was once a hotel, a restaurant, and a nine-hole golf course. (Courtesy of Joyce Wood.)

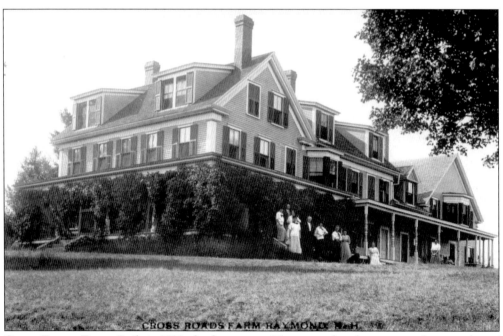

CROSS ROADS FARM. Built in 1780, the farm sat on 20 acres and took in visitors for a number of years. (Courtesy of Joyce Wood.)

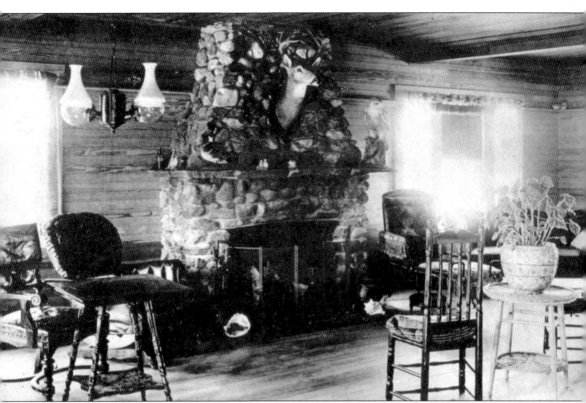

MUSIC ROOM AT CROSS ROADS FARM. This photograph of the inside of the Cross Roads Farm was taken in 1914. (Courtesy of the Steve Goldthwaite collection.)

GOVE FARM. This home, located at 48 Nottingham Road, was built in 1750 and was used for quite some time as a poultry farm. A number of the old farm buildings are still standing and visible from the street. (Courtesy of the Raymond Historical Society.)

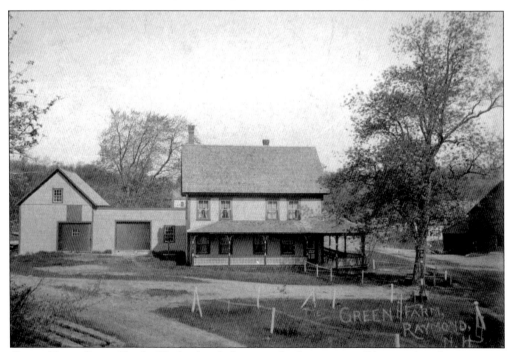

GREEN FARM. Owned by the Healey family for years, this home was well known for taking summer boarders along Scribner Road. The Healeys were early settlers in Raymond, and they built this house in 1877. Today it is a private residence. (Courtesy of the Raymond Historical Society.)

HARRIMAN ROAD HOUSE. Grover Waterhouse, a local businessman and landowner, owned this home when this picture was taken. Back then, the home was located on Main Street past the Pecker Bridge, where the GMS Pizza parking lot presently is. It was moved to 7 Harriman Road and is a private residence. (Courtesy of the Raymond Historical Society.)

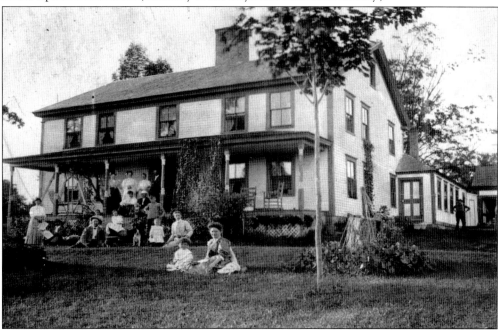

HARRIMAN FARM. The Harrimans came from Yorkshire, England, to Rowley, Massachusetts, eventually settling in Raymond as one of the town's earliest families. In the 1820s, the Harrimans built this house, which is no longer standing. It was located on Harriman Hill Road, which was named for the family that had a number of farms along the road. (Courtesy of Jean Waterhouse Edgerly Saladino.)

THE BATCHELDER HOUSE. On the outflow to Onway Lake, this farmhouse had orchards and a sawmill in addition to taking on summer boarders. The owners, Mr. and Mrs. Vernon Batchelder, had two daughters, Jean and Rosamond, and they all lived in an apartment on the side of the house. The farmhouse was located at the end of Scribner Road, and the property was eventually sold to Mary T. Sargent, who created a girls' camp on the land. (Courtesy of the Raymond Historical Society.)

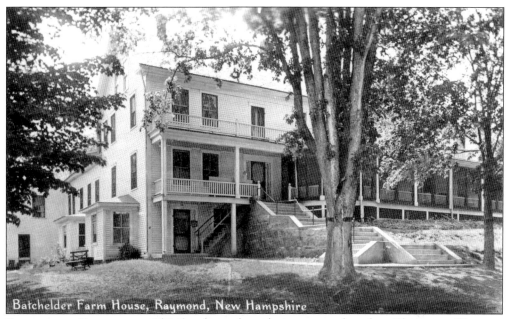

BATCHELDER FARMHOUSE. This farmhouse brought in summer boarders. There were 22 rooms and a large dining room in the basement that served both visitors and townsfolk. (Courtesy of Joyce Wood.)

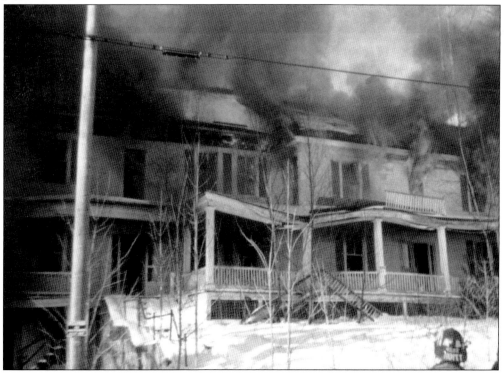

BURNING OF BATCHELDER HOUSE. The Raymond Fire Department participated in a controlled burn of the old Batchelder farmhouse after it fell into disrepair in the late 1960s. (Courtesy of the Raymond Historical Society.)

BATCHELDER BUNGALOWS. This was one of many bungalows that were used as rental cabins for the Batchelder house. This side faced Onway Lake, and it burned down in January 1991. (Courtesy of the Raymond Historical Society.)

BATCHELDER CAMP-LEDGEMERE. Another part of the old Batchelder camps is seen here. (Courtesy of the Steve Goldthwaite collection.)

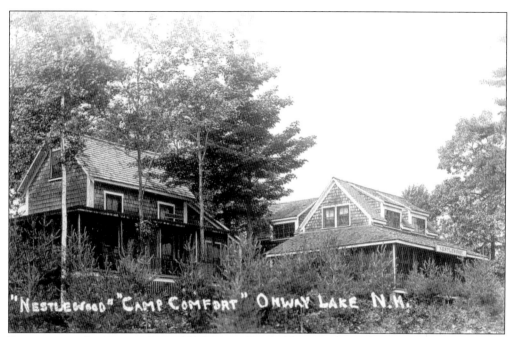

BATCHELDER COTTAGES. Owned by Vernon Batchelder, Nestlewood and Camp Comfort were rental cabins at the Batchelder farmhouse. (Courtesy of Joyce Wood.)

BATCHELDER HOUSE RECREATION HALL. This recreation hall was on the grounds of the Batchelder farmhouse. (Courtesy of Joyce Wood.)

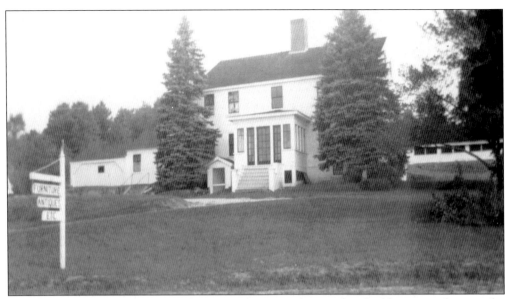

BENJAMIN POOR HOMESTEAD. Once a private residence, this building now houses the Walnut Hill Conference Center at 81 Chester Road. The house was built around 1790, and this photograph was taken in 1959. There is a stained-glass window in the Congregational church given in memory of Benjamin Poor and his wife, Alice. (Courtesy of the Raymond Historical Society.)

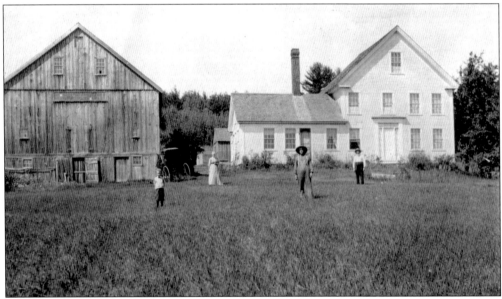

DEARBORN HOME. The Dearborns were one of the founding families of Raymond. From left to right are Forest Leslie Dearborn, Martha M. Dearborn (his grandmother), Navah Dearborn (his father), and Henry Freeman Dearborn (his grandfather). This photograph was taken around 1910. Forest would go on to be "the old bachelor milkman" of the town. He left his home and land on Onway Lake to the Methodist Church because he did not like the Town of Raymond and did not want the town owning his land. The church then, ironically, sold the land around Onway to the town. (Courtesy of the Steve Goldthwaite collection.)

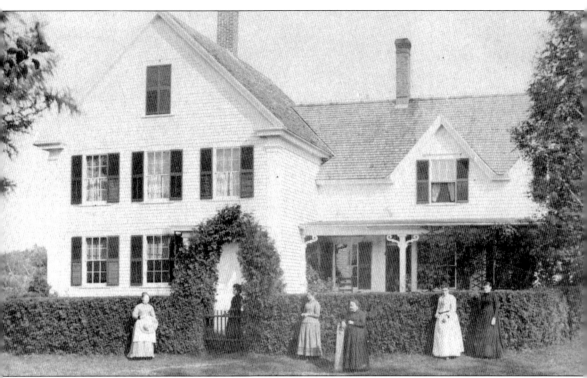

ELISHA PRESCOTT HOME. Prescott Road was named after the Prescott family, one of the early families to settle in the town. Elisha Prescott was said to have gained a wealthy estate through industry and labor. His home, on 34 Prescott Road, was built in 1820. When he died in 1875, he was 97 years, 3 months, and 11 days old. He was, as far as anyone can tell, the person who had attained the greatest age in town at that time. Asa Poor later lived to be over 100. (Courtesy of the Raymond Historical Society.)

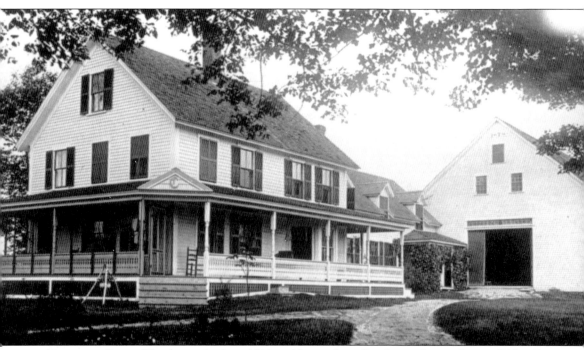

ELMWOOD FARM. This home, built in 1820 on Nottingham Road, was the residence of John E. Cram, Raymond's Civil War hero. At Spottsylvania on May 12, 1864, Cram's regiment's color bearer was shot, and he carried the colors after that. When his regiment was retreating, he made the historic reply, "Bring the regiment up to the colors," which inspired courage in his men to keep on fighting. Shortly after, Cram was wounded severely, taken off the field, and was unable to go back into battle. (Courtesy of the Steve Goldthwaite collection.)

Seven
RAYMOND RESIDENTS

VIVIAN CRAM. Six-year-old Vivian Cram was the granddaughter of Raymond's Civil War hero John E. Cram. Vivian was the person who pulled the rope that unveiled the soldier's monument on the town common. She later married Charles Wesley, a teacher who took her to Mexico where he was teaching. There she died, still a young woman, and is buried there in a lonely grave. (Courtesy of the Steve Goldthwaite collection.)

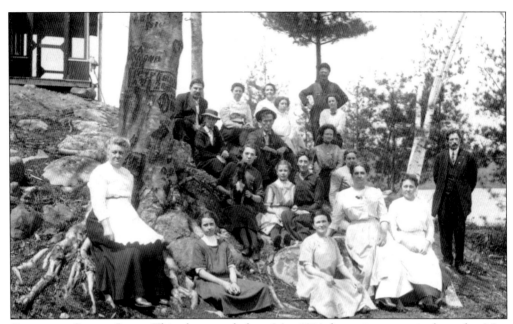

GROUP ON ONWAY LAKE. This photograph from May 1914 shows, in no particular order, Mrs. George "Kid" McClure, Mazzie Brown, Sadie Dudley, Mrs. Brown, John Prescott, Beatrice Shepard, Mildred Brown, Carrie Edgerly, Helen Gould, Bass Gould, Victor Brown, Ed Dudley, Sadie Cram, Mertie Files, Will Emerson, Nellie Emerson, George McClure, and Ella Prescott on Onway Lake. (Courtesy of the Steve Goldthwaite collection.)

IBER HOLMES GOVE. Born in 1905, Iber Holmes Gove graduated from RHS before attending Keene Normal School and receiving a bachelor of arts degree from the University of New Hampshire. She would eventually go on to receive her master's degree from Columbia University. Gove taught at RHS beginning in 1929 and eventually taught in Berlin as well. She was active not only in the school but in the town as well. When the new high school was built in 1988, the middle school was renamed in honor of her. Ironically, it was her husband Norris Gove's father, Sherburn, who built the original Raymond Consolidated School in 1917. (Courtesy of the Iber Holmes Gove Middle School.)

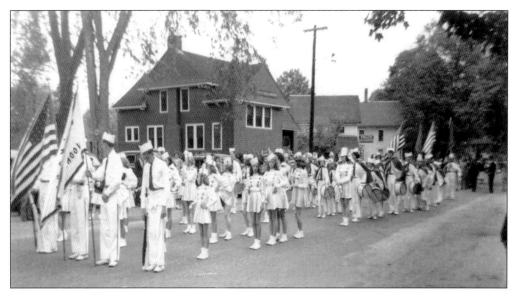

RHS DRUM AND BUGLE CORPS. This photograph shows RHS's drum and bugle corps lined up in front of the library in the 1950s on Memorial Day. (Courtesy of the Raymond Historical Society.)

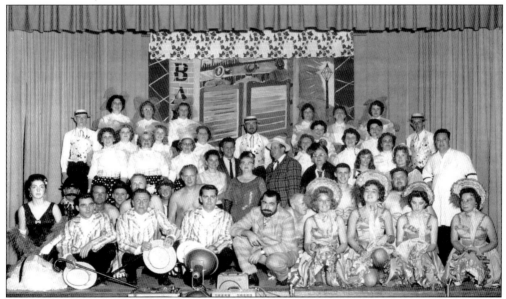

NAUGHTY NINETIES. In August 1964, the town held its bicentennial celebration, which consisted of a full week of activities for the whole family. What people remember most was the PTO production *Naughty Nineties*. The cast included, in alphabetical order, Flora Audette, Shirley Barnes, Omer Bernard, Frank Case, Peg Case, Bob Castonguay, Emma Castonguay, Mildred Chamberlain, Eleanor Cottrell, Patty Cottrell, Diane Dickinson, Barbara Eaton, Zeke Eaton, Sadie Gelinas, Gwen Greenwood, Bert Houle, Edward Hunter, Joyce Hyer, Carol Ann Karpinski, Jane Karpinski, Bertha Langford, Rita Leonard, Tom Leonard, Alice Maloney, Cliff Perkins, Priscilla Perkins, Randall Perkins, Shirley Perkins, Iris Richard, Caroline Severence, Inez Smith, Melverda Smith, Ramona Stevens, Frank Thompson, Martha Waterman, Dodie Willoughby, and Robert Willoughby. (Courtesy of the Raymond Historical Society.)

FOREST DEARBORN AND GRANDMOTHER. Forest Leslie Dearborn (right) is seen with his grandmother Martha M. Dearborn on their family farm. Forest would go on to be very active in the town's Masons' group. (Courtesy of the Steve Goldthwaite collection.)

DAVID FELLOWS AND MATTIE DODGE. David Fellows and Mattie Dodge were local entertainers who performed skits in Raymond and surrounding towns. This photograph was taken in 1914. (Courtesy of the Steve Goldthwaite collection.)

NEAL AND JACK WELCH. Brothers Neal and Jack Welch are shown standing in front of their father Ai's business in July 1953. Ai Welch was a member of the first graduating class of the Raymond Consolidated School. He and his wife, Josephine, who was the daughter of Dr. Fred Fernald, had seven children. Josephine taught history and Latin at the consolidated school while Ai began his fuel business in 1939. He was in the oil business for 40 years, and he and his sons held the school transportation contract for a like period of time. His father, Frank Welch, ran the River House for a time. Ai was also a town selectman from 1928 until 1940. (Courtesy of Alison Welch Lacasse.)

PASTOR THOMPSON AND HIS WIFE. Albert Thompson took over as reverend of the Congregational Church in 1888 and served in that post until he passed away in 1916. His wife, Arvilla "Babe" Thompson, taught at the Gile School. (Courtesy of the Steve Goldthwaite collection.)

DR. GEORGE GUPTILL AND THE TRUE SISTERS, C. 1890. The doctor married Nellie May True (left) on June 4, 1890, and a son, Bernard, was born the following June. Nellie would die the following year at the age of 20. The front center stained-glass window in the Methodist church was given in her honor by the doctor. The doctor would go on to marry her sister, Lizzie True (right), on February 12, 1896. (Courtesy of Sally Guptill Paradis.)

JOHN T. AND EMMA BARTLETT. John T. Bartlett was a judge who resided in Raymond with his wife, Emma. Together they had two sons and two daughters that they raised in town. Emma taught in New Hampshire schools for 10 years, in which 4 of those years were in the Raymond schools. She went on to become one of the first women in the New Hampshire state legislature. She was elected in the early 1920s as a democratic representative, and she was deeply involved in the Women's Civic Club. She also thought of capital punishment as "legalized crime." She was against war of any kind, and she voted in favor of the 48-hour workweek law. (Courtesy of Vance Ryan.)

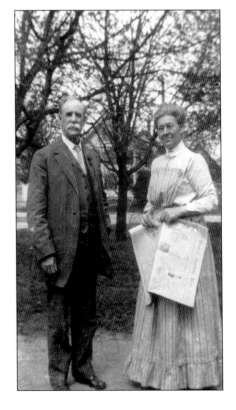

DR. GUPTILL, C. 1914. This photograph of Dr. George Guptill was taken on his 50th birthday. He was born on September 5, 1864, in Berwick, Maine, and he graduated from medical school in 1888. That year, he moved to Raymond and began a medical practice. Two years later, he married a local girl, Nellie True, and together they had a son, Bernard. After Nellie died, the doctor married her sister Lizzie, and together they had three children, Nellie, Pearl, and George Jr. He successfully ran for state senator in 1910 and served until his second wife died in 1911. Dr. Guptill passed away on December 10, 1927, at the age of 63. (Courtesy of Sally Guptill Paradis.)

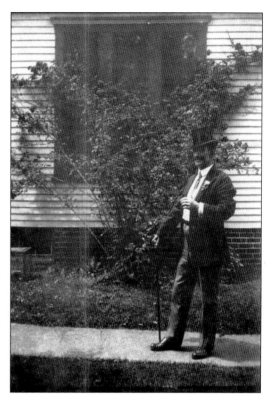

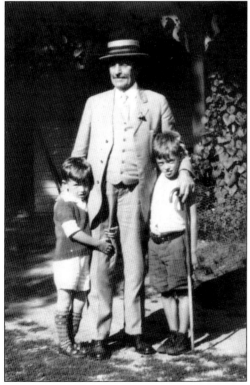

DR. GUPTILL AND GRANDSONS. This c. 1927 photograph shows Dr. Guptill with his grandsons who would become two of the four Raymond graduates to die in World War II. Kenny, on left, was Pearl Guptill Eccelston's only child, and Herbert, on right, was Nell Guptill Brown's only child. (Courtesy of Sally Guptill Paradis.)

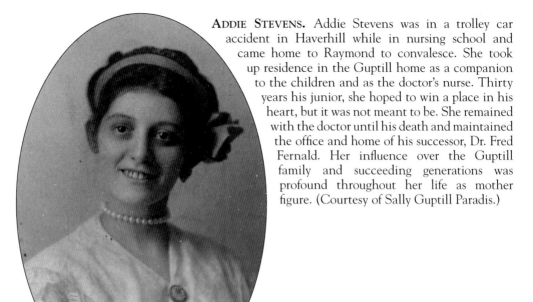

ADDIE STEVENS. Addie Stevens was in a trolley car accident in Haverhill while in nursing school and came home to Raymond to convalesce. She took up residence in the Guptill home as a companion to the children and as the doctor's nurse. Thirty years his junior, she hoped to win a place in his heart, but it was not meant to be. She remained with the doctor until his death and maintained the office and home of his successor, Dr. Fred Fernald. Her influence over the Guptill family and succeeding generations was profound throughout her life as mother figure. (Courtesy of Sally Guptill Paradis.)

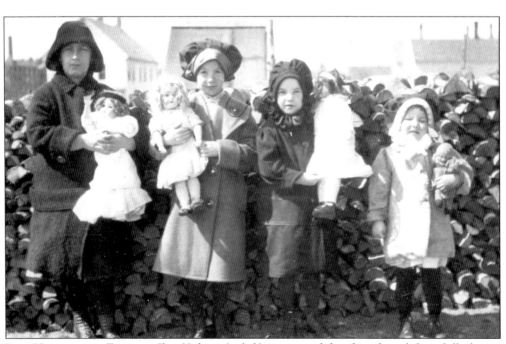

IBER HOLMES AND FRIENDS. Iber Holmes (at left) is seen with her friends and their dolls during Easter 1914. Holmes would eventually teach in Raymond's schools and would be honored by having the middle school named after her in 1988. (Courtesy of the Raymond Historical Society.)

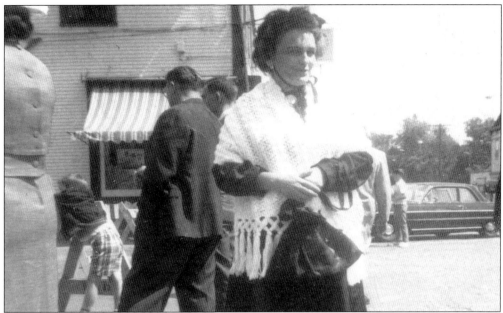

SHIRLEY JONES BARNES. Shirley Jones Barnes, born in Swampscott, Massachusetts, married Harold Barnes from Raymond. Shirley would go on to write a history of Raymond in 1964, published in time for the town's bicentennial. She is shown here, dressed in costume, in front of Candyland at the town's 200th anniversary parade. (Courtesy of the Raymond Historical Society.)

SUSAN B. HUTCHINSON. Susan B. Hutchinson came from a well-to-do Pennsylvania steel family that enjoyed vacationing at Raymond's lakes. When Hutchinson was 75, she completed her lifelong dream when she opened the Hutchinson Summer Theater off Long Hill Road. She ran the theater until her death just a few years later. (Courtesy of Susan Hilchey.)

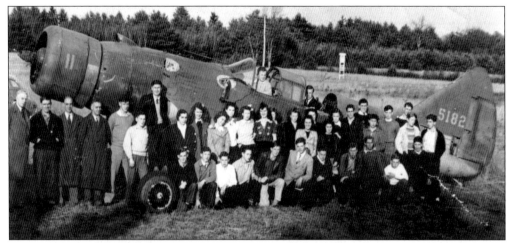

RAYMOND'S AIRPLANE. This government surplus airplane was given to RHS in 1943 to stir up war interest. A hangar was built around it, and eventually the plane was given to Pinkerton Academy. Townspeople volunteered labor and equipment to build its two runways. Pictured are George H. Harmon (superintendent of schools, retired in 1947), Walter Quimby, Hammond Young (principal), Andrew Fasekis, Bill Rollins, Duke Lyman, Carlton Paquette, Edith Hammond, Marilyn Titus, Yvonne Greenwood, Edna Severance, Lillian Orfield, Alice Purington, Sylvia Moulton, Helen Fasekis, Doris Greenwood, Charlena Littlefield, Barbara Kebbe, W. Noyes, Robert Cammett, Martha Moody, Henry Plant, Don Smith, Paul Smith, Frank Mafera, Frank Guyette, Warren Rollins, Carrol Sanderson (agriculture teacher), and in the cockpit, Hughin Holt. (Courtesy of the Raymond Historical Society.)

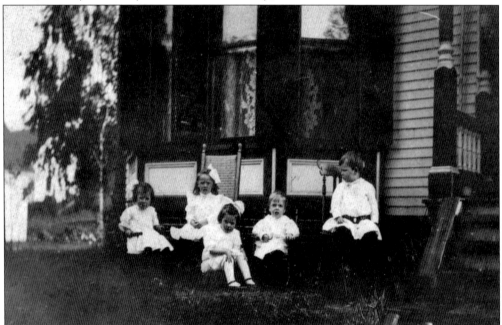

BIRTHDAY BABIES. From left to right are Ruby Folsom, Priscilla Sanborn, Ruth Ladd, George Guptill Jr., and Josiah Gordon. These children were all born the week of June 14, 1906, and all were delivered by Dr. George Guptill. They are shown here on the week of their second birthdays. (Courtesy of Sally Guptill Paradis.)

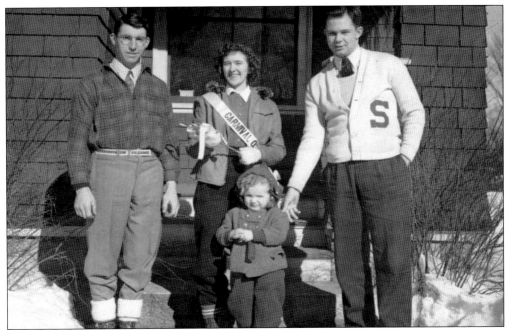

CARNIVAL QUEEN. In 1940, the winter carnival was run by the Outing Club, which would crown a winter carnival queen. In front of the library, from left to right, are Jonathan Quimby, queen Dorothy Andrews, Cynthia Holt Gagnon, and Sumner Gill, the young minister of the Congregational Church. (Courtesy of Shirley Holt Dodge.)

CRAM FAMILY. John E. Cram (looking away) is seen on the porch of his family house on Nottingham Road with his children and grandchildren. This photograph was taken on November 30, 1911. (Courtesy of the Raymond Historical Society.)

AI WELCH. Born in 1900, Ai Welch was one of the four members in the first graduating class of RHS in 1918. He went on to marry RHS Latin and history teacher Josephine Fernald, who was the daughter of town doctor Fred Fernald. They went on to have seven children together. Welch was a town selectman from 1928 through 1940. In 1939, he started his fuel business that would run for the next 40 years. With his sons, he also owned and operated the town's school buses. Welch passed away in 1975. (Courtesy of the Raymond 225th Anniversary Souvenir Booklet.)

GLENNA CAMMETT. A member of RHS's class of 1922, Glenna Cammett penned the words to the school song "Fair Raymond," sung to the tune of "Believe Me If All Those Endearing Young Charms." Her son Robert P. Cammett was a graduate of RHS in 1945 and was a basketball and baseball standout. He was inducted into the RHS Athletics Hall of Fame in 2005. He was very involved in the town and the school, even in his later years. He passed away 2007. (Courtesy of Robert H. Cammett.)

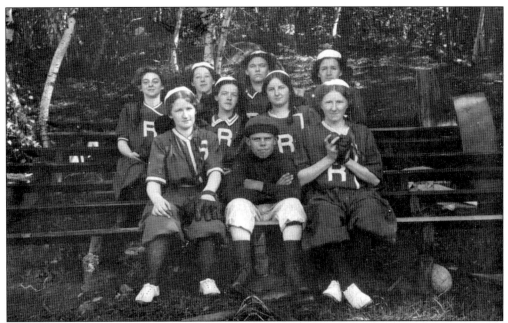

THE GIRLS' TEAM. These girls played a baseball game on September 16, 1911, against some local young men. The men threw left-handed and were handicapped with dresses, and yet the score was the men 25, and the women 13. Pictured are, from left to right, (first row) pitcher Edith Locke, catcher Phil Fox, and first baseman Dora Christie; (second row) second baseman Daisy Lyman, shortstop Ethel Moore, third baseman Mrs. Cleve Allen, right fielder Hazel McClure, left fielder Alice Furber, and an unidentified center fielder. (Courtesy of the Steve Goldthwaite collection.)

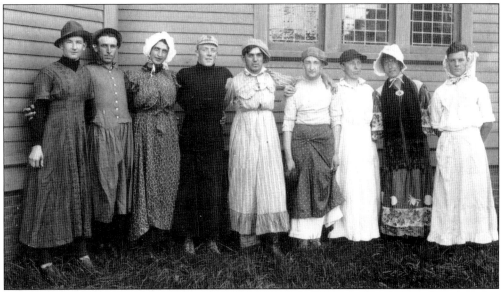

THE BOYS' TEAM. The boys' team included pitcher Frank Lyman, catcher Fred Lyman, first baseman Roger Ladd, second baseman Cleve Allen, shortstop Byron Tilton, third baseman Triff Brusso, left fielder Maynard Brown, center fielder Robert Bartlett, right fielder ? Burke, and (not pictured) umpire Joe Langford. This picture was taken in front of the Congregational church. (Courtesy of the Raymond Historical Society.)

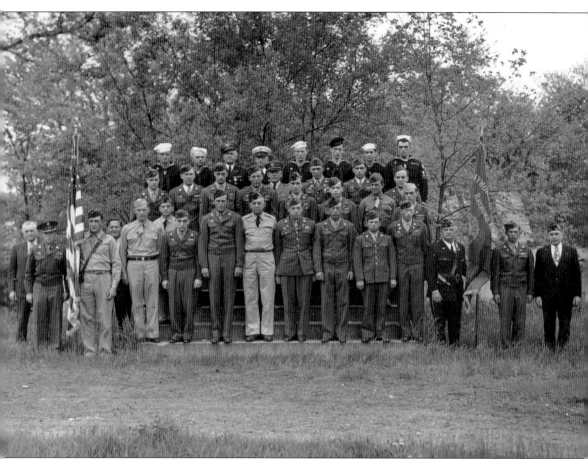

WORLD WAR I AND WORLD WAR II VETERANS. Standing on the concrete steps of the old town hall in 1946 are the charter members of the VFW. From left to right are (first row) Charles Armstrong, Willis French, Karl (Bob) Orfield, Bill French, Roland Howard, Charles Pellerin, Rudolph Quintal, George Edwards, Byron Page, Richard Taylor, Roger Brown, Arthur Mudge, Leonidas Taylor, Rosario Beaudoin, Cedric Brown, and Charlie Peaslee; (second row) Custer Quimby, Gordon Traver, Frank Rock, Winston Edwards, Fred Stewart, Eddie Thompson, Creighton Wilbur, Charles Piper, Brownie LeBlanc, George Andrews, Bing (Adelard) Quintal, and Leonard Watt; (third row) Clarence "Stubby" Robbins, Burgess Robinson, Omar "Kid" Venzina, Russell Harrington, Red Gilmartin, Harry Kells, Wilton Clark, and Romeo Levesque. (Courtesy of the Raymond Historical Society.)

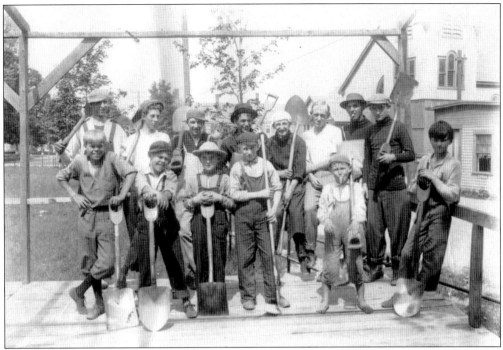

WORKING ON THE COMMON. This photograph, take in the early 1900s, shows a group of local boys building some type of platform stand on the common. (Courtesy of the Raymond Historical Society.)

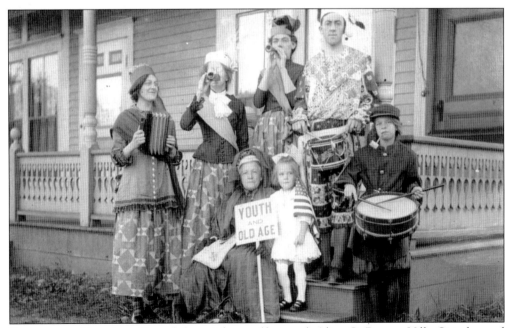

YOUTH AND OLD AGE. From left to right are (first row) Alice C. Brown, Villa Quimby, and Genieveve Dodge; (second row) Fanny Whitney, Helen Prescott, Anna Colcord, and Bernard Guptill. (Courtesy of the Steve Goldthwaite collection.)

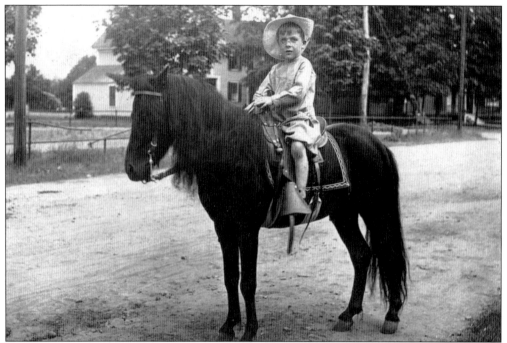

GEORGE GUPTILL JR., C. 1912. This photograph shows young George Guptill Jr. riding his pony around the common. Guptill was known to have free reign of the town due to the fact that his mother had passed away and his father was busy being the town doctor. Notice the scraped knees and face. (Courtesy of Sally Guptill Paradis.)

GEORGE WITH NEW ELECTRIC STOVE. Guptill, an employee of New Hampshire Electric Company in the late 1930s, brought this new electric stove to the Raymond Consolidated School for a demonstration. (Courtesy of Sally Guptill Paradis.)

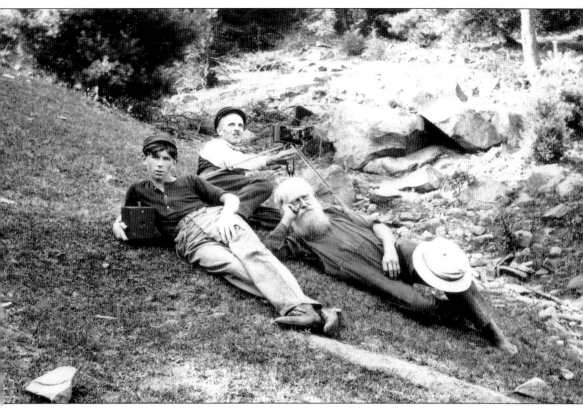

GEORGE GOODRICH. George Goodrich was a farmer and photographer who owned land near Pawtuckaway Lake. He and his wife, Susie, would often come into town to sell produce and maple syrup to local grocers. His long white hair and beard, bare feet, and tattered clothes often shocked visitors to Raymond, but that did not matter to Goodrich. He loved to read and kept a daily diary from 1905 to 1910. When he died in the 1920s, he left money and books to the town of Raymond in his will, which was not probated until 1967. Raymond resident Paula Wood recently published a book on Goodrich. Pictured on the left is Edward Wilkinson, Goodrich is on the right, and the man in back is unidentified. (Courtesy of the Raymond Historical Society.)

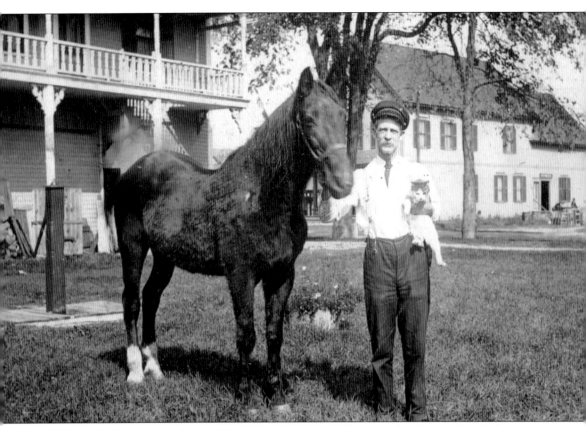

MAN WITH CAT. This photograph is most likely David Whittier, taken behind his clothing store on Main Street. (Courtesy of the Steve Goldthwaite collection.)

GROVER WATERHOUSE C. 1917. Born in 1908, Grover Waterhouse was a successful local businessman and landowner. He is shown here at age nine. Waterhouse was known as a young man who would save up his money and buy parcels of land. As he grew older, his land holdings grew quite extensive. (Courtesy of the Raymond Historical Society.)

WATERHOUSE ON HORSE. Waterhouse, in addition to being the local Ford dealer and garage owner, raised and raced horses until he was 88. In Waterhouse's barn, still located on Main Street, he kept both stallions and mares. Taking part in standard breed racing, Waterhouse won several New Hampshire state championships. Waterhouse Track, located on Main Street along the Lamprey River, was used as a training track for trotting breeds and show roadster ponies. This photograph of Waterhouse was taken when he was in his 80s. (Courtesy of Jean Waterhouse Edgerly Saladino.)

CHRIS MATARAGAS. PFC Chris Mataragas was one of four young Raymond men killed in World War II. He served in the U.S. Army Medical Corps and died in Germany on October 3, 1944. (Courtesy of the Raymond Historical Society.)

ELMER D. WHEADON. SSgt. Elmer D. Wheadon was a gunner in the U.S. Army Air Corps and was shot down over Switzerland on October 1, 1943. Wheadon was 19 when he enlisted in August 1942, right after graduating from RHS. He was awarded the Purple Heart posthumously and was the first casualty reported from the town. The Maple-Wheadon post of the VFW in town bears his name. (Courtesy of the Raymond Historical Society.)

HERBERT W. BROWN. 1st Lt. Herbert W. Brown was reported missing in action on August 17, 1943, after his plane was shot down over the North Sea returning to England after a bombing mission over Germany. He is memorialized at the Netherlands American Cemetery in Margraten, Netherlands. A member of the 8th U.S. Army Air Corps, he was the recipient of the Air Medal and the Purple Heart. (Courtesy of the Raymond Historical Society.)

KENNETH ECCLESTON. 1st Lt. Kenneth Eccleston went missing in action on December 20, 1943, after his plane was shot down while on bombing mission over Bremen, Germany. Memorialized at the Cambridge American Cemetery in Cambridge, England, Eccleston was the recipient of the Air Medal with three oak leaf clusters. He also was part of the 8th U.S. Army Air Corps. (Courtesy of the Raymond Historical Society.)

Bibliography

Barnes, Shirley Jones. *History of Raymond, NH: 1764–1962.* Concord: Capitol Offset Company, 1964.

Fullonton, Joseph. *History of the Town of Raymond.* Dover, NH: Morning Start Job Printing Press, 1875.

Pictorial History of Raymond, NH: 1764–1976. Raymond Historical Society, 1976.

The Granite Monthly Legislative Number. January 1923.

Wood, Paula Casey. *The Barefoot Farmer of Pawtuckaway: The Story of George Goodrich.* Exeter, NH: Publishing Works, 2007.

Index

Cram, John E., 20, 104, 115
Cram, Vivian, 20, 71, 75, 105
Dearborn, Forest Leslie, 102, 108
Gould, Dr. True M., 14, 66, 72
Gove, Iber Holmes, 40, 69, 75, 106, 112
Guptill, Dr. George, 66, 110, 111, 112, 114
Guptill, George Jr., 42, 69, 114, 120
Holmes, Lewis W., 40 56, 60
Hutchinson, Susan B., 27, 113
Waterhouse, Grover, 31, 56, 97, 123
Welch, Ai, 67, 84, 109, 116
Welch, Frank, 67, 109
Welch, Jack, 109
Welch, Neal, 79, 80, 109
Whittier, David, 61, 72, 122

Across America, People are Discovering Something Wonderful. Their Heritage.

Arcadia Publishing is the leading local history publisher in the United States. With more than 3,000 titles in print and hundreds of new titles released every year, Arcadia has extensive specialized experience chronicling the history of communities and celebrating America's hidden stories, bringing to life the people, places, and events from the past. To discover the history of other communities across the nation, please visit:

www.arcadiapublishing.com

Customized search tools allow you to find regional history books about the town where you grew up, the cities where your friends and family live, the town where your parents met, or even that retirement spot you've been dreaming about.